Fashion Photography Now

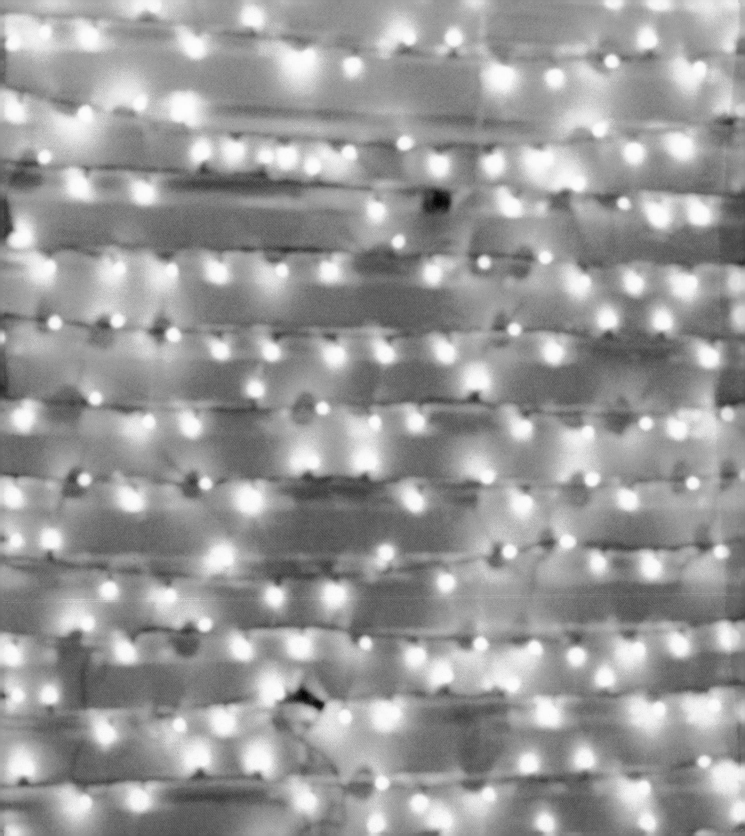

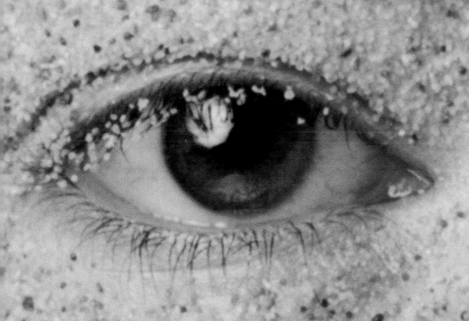

Fashion Photography Now

Edited by Catherine Chermayeff Harry N. Abrams, Inc., Publishers

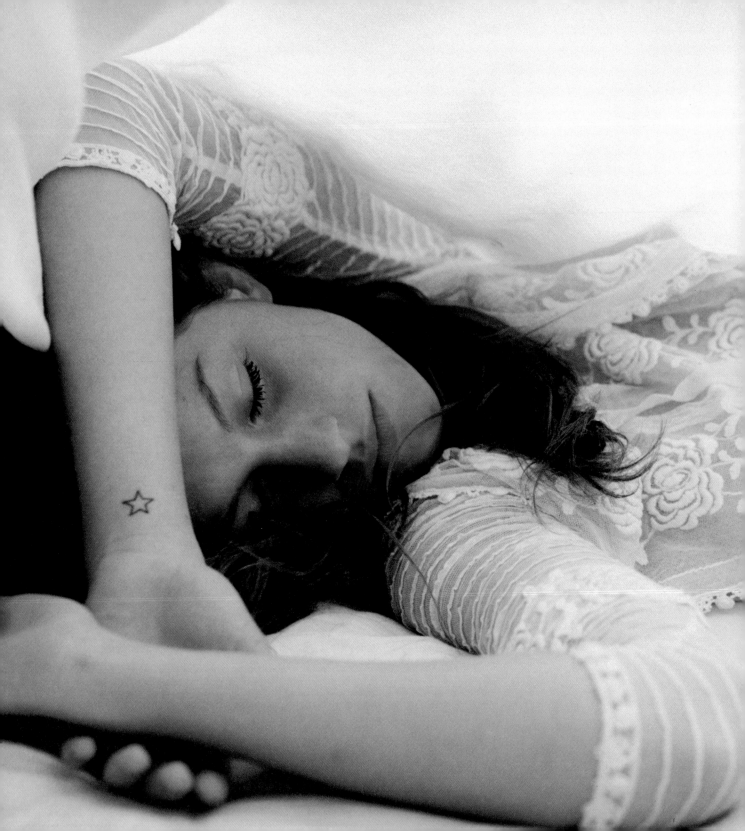

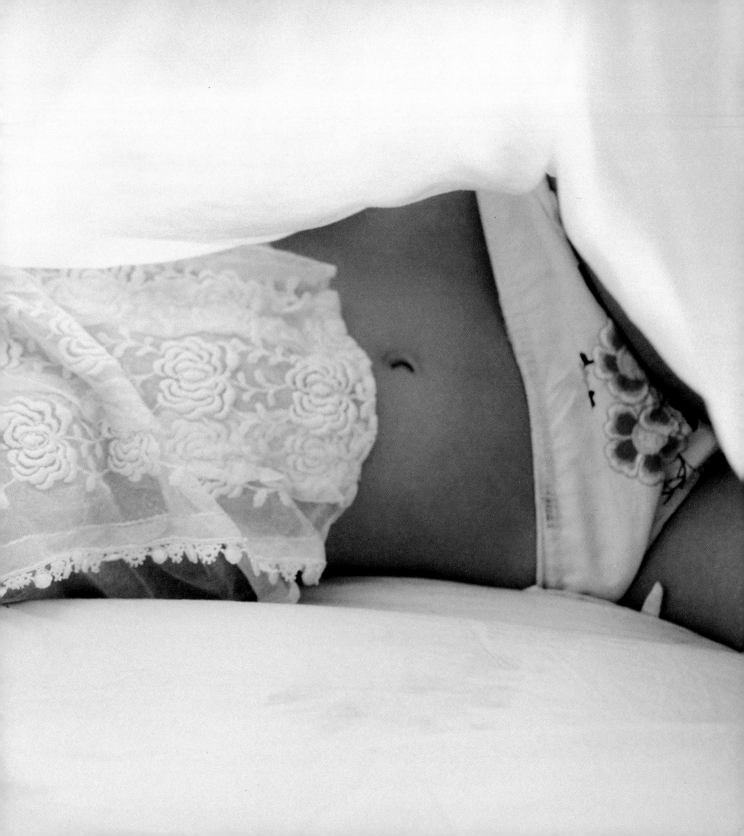

Introduction

What is it that is so attractive about fashion and fashion photography? The moment you are ready to give up on it you find yourself speechless, staring at an image in a fashion magazine. The real world silently recedes around you. You are enveloped by an image you thumbed past the day before. The image absorbs you and slowly you slip away into a world of myths and fairy tales played out on the glossy pages of a five-dollar magazine. Like the Sirens, fashion photography calls you back.

I don't remember how old I was when I first became aware of style and fashion. When I was about nine or so my mother came to collect me from school because I was sick. She saw immediately that I was more lonely than sick so she suggested a trip to the movies. I can't remember what the movie was called but it was French, it took place at a ski resort (I think), and it starred Alain Delon (I'm sure). And it was definitely about style. For years I pored over books and magazines about the movies, mostly French and Italian, made by Truffaut, LeLouche, Godard, and Antonioni. The pages were filled with glamorous houses and desirable moments, and always clothing, dresses – in a word, fashion.

Since then, fashion magazines have kept me company – a sort of magical friend from childhood. Fashion photographs are always powerfully appealing, with their illumination into other worlds and other possibilities.

I grew up in a house where the way things looked was what counted. I learned to trust my eyes. I learned to be visually confident about what I liked, and what I thought looked good. And I practiced every day by looking at fashion magazines. I practiced until it became a way of life. Fashion photography became a companion. The newsstand my home away from home.

This collection of fashion photographs is unconventional – although I didn't necessarily intend that when I began. I have included familiar names, contemporary icons such as Peter Lindbergh, Paolo Roversi, Lillian Bassman, Ellen Von Unwerth – mainstream fashion photographers who have defined and continue to dominate traditional, classic advertising and editorial fashion photography.

The criteria was fashion photography *now* – and that also includes the up-and-coming. Some images are published here for the first time, and this book also marks the debut in print for such photographers as Jennifer Robbins, Gillian Laub, Umberto Stefanelli. The photographers are from all over the world – from the United States to Europe and Israel – and of all ages – from twenty-two to eighty-three.

When I began this process of looking and choosing, I started with my own clipping piles, which also double as my diaries. My clips have been culled from any place or any thing I like and for any reason. For years now I have collected and kept things in these tearsheet-like piles. I'll clip practically any image: something familiar, something strange, something pretty, something grotesque. I never know exactly what makes me tear it out. But tear them out I do.

Sometimes I imagine that the perfect magazine would be my own clipping file – every single page something that I like or want to remember. The inclination to collect comes to me naturally. My father keeps everything: old car-squashed gloves found on the street, travel tags ripped off suitcases after a trip, letters addressed to him where his name is misspelled. His collections of images and objects are endless. A Paris Metro ticket or a smashed Coke can; objects both two- and three-dimensional spill out all over his studio. My father takes these remnants and goes a step further: he turns them into posters and collages, collections. Mine stay neatly in piles and notebooks – old school composition books and contemporary leather binders.

Putting together a book of fashion photography is a process that changes along the way. One photographer leads to another and another and suddenly the collection is not at all what I expected when I started.

The seed for this project was an international fashion photography exhibition I collaborated on a year ago. I had been looking at a lot of contemporary work, including editorial, advertising, personal and, unpublished. I began to find a thread that held together the images I chose.

Traditional fashion photography had a purpose. It was always about clothing and about presenting clothes in situations that were flattering and beautiful. Today, fashion photography now is more about innuendo. It captures a mood, a moment. These two places are coming closer together and that is where the most interesting, and most unexpected, photographs are being made. It is that edge that I wanted to explore.

The last few years have produced as many technical possibilities in photography as the last 150 years. The computer has transformed what can be done, from the slick perfection of Dah Len's flawless hyper-real models to Lillian Bassman's digitally altered images.

Bassman still works exactly the way she did for *Harper's Bazaar* in the 1940s and 50s, only now she adds another step. She still shoots her elegant and graceful images, still goes into the darkroom and does her magic with bleach and cotton balls but the saturated colors are artificial. Stephane Sednaoui's models melt away like chocolate. As a contrast I've included the whimsical and stripped-down images of collaborators Alex + Laila, which are carefully composed and spare.

From its inception, fashion – and the way it has been illustrated in photographs – has both inspired and perpetuated an unattainable dream. Despite changes both technical and cultural, it still does. With the ability to transport its viewer into imaginary worlds, fashion photography has shaped a cultural aesthetic that is both sought after, envied, and sometimes loathed. As a reaction, today fashion photography can be displeasing and ugly – daring you to like it, to want it, to long for it. The fashion photographers who present these tableaux both navigate and dictate our evolving relationship with beauty and desire.

Fashion photography seeks out the voyeur in all of us. It documents our contradictions – the difference between what we are seeing and what we are feeling – and challenges our fundamental sense of seduction and glamour. Even the most demanding of images now become fodder for perusal of fashionable clues. This more subtle relationship between photographic reality and what we notice is the new turf of fashion photography.

For a long time fashion photography has dictated a standard of beauty that feeds off collective dreams, with its advocation of romantic settings and a more glamorous world than the one we know. It has shaped an ideal vision of a modern culture that can never truly be found, much less acquired. In essence, fashion photography is about a sort of meta-perfection. It delves into the contradictions of our relationships with what we wear and how we see ourselves. It plays with our dreams, and some-

2 **Donald Christie** 1998, Frank

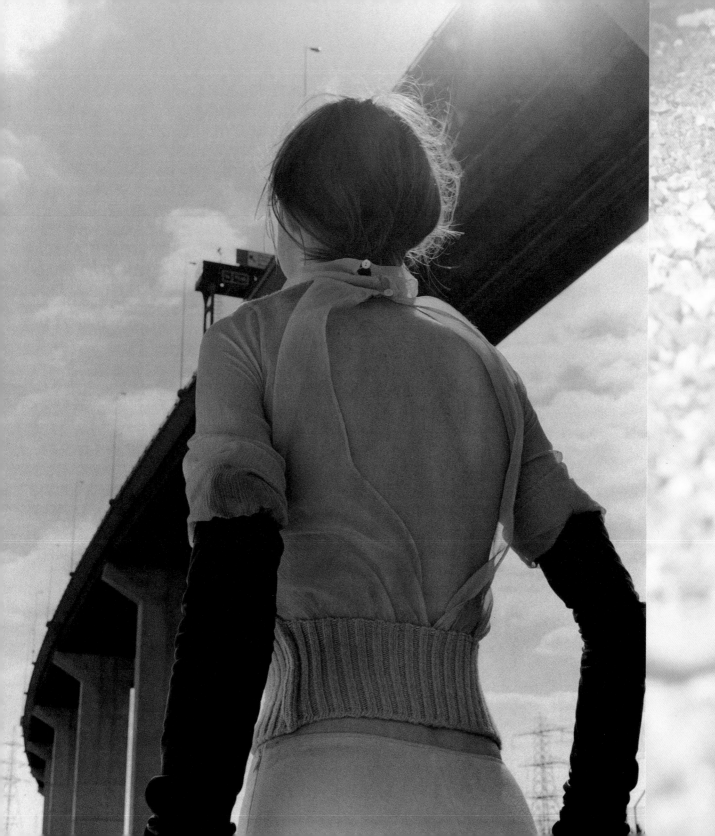

times too with our fears, depending on our own personal fashion horizons. Fashion photography attempts to document the struggle – the gap, as it were – between self-knowledge and our ideal self.

There is an undeniable trend toward the documentary style in fashion portraits. Young fashion photographers look to the work of fine art photographers like Nan Goldin, Tina Barney, and Cindy Sherman. For example, Elaine Constantine is a wonderful young British photographer shooting for *i-D, The Face,* and *Vogue* magazines. Her fashion photos remind me of Tina Barney; both women would seem to inhabit similar places. Tina Barney's created world is staged, yet it feels real, almost documentary, whereas Elaine Constantine uses that same strategy but applies it to fashion. By addressing the significance of seeing and the nature of perception, both attempt to redefine our identity in relationship to the image before us. Is one more pure than the other? I don't know.

These urban and suburban narratives are being incorporated into a world previously monopolized by fantasy. The emergence of this style of photography, among other things, was born out of a need to make fashion more accessible. But the effect on the actual photography has been vast. Today, fashion photography draws from the same sources and conflicts as do art photography and photojournalism. It takes as its subjects who we are and how we fit into the world around us. Who is doing the seeing and why?

Since the middle of the twentieth century, fashion photography has confirmed its place in the history of photography. Roberta Smith, writing in the *New York Times,* said, the "mutual attraction and natural overlap between art and fashion has become an unavoidable part of contemporary visual culture. Art photography and fashion have become virtual Siamese twins." To find great fashion photography is to look well beyond the more traditional places such as the big glossy magazines.

The spectrum of what is and isn't current and fashionable has broadened. Haute couture and street wear coexist and even play off each other. Fashion photography subtly reconfigures the conditions of traditional images. Gangsters in Dolce and Gabbana, middle-aged men in CK underwear from Long Island retrieving their mail, beautiful, sullen-looking young girls jumping out of pools, truck drivers in their cabs filled with pin-ups . . . these are the earmarks of today's fashion photograph. Effectively, all are staged, all are real, all are identifiable. They are all us but somehow not us – not exactly.

Catherine Chermayeff
Spring 2000

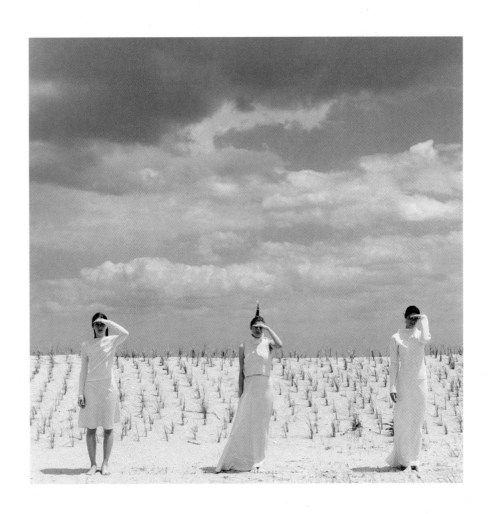

4 **Alex + Laila** 1999, Detour

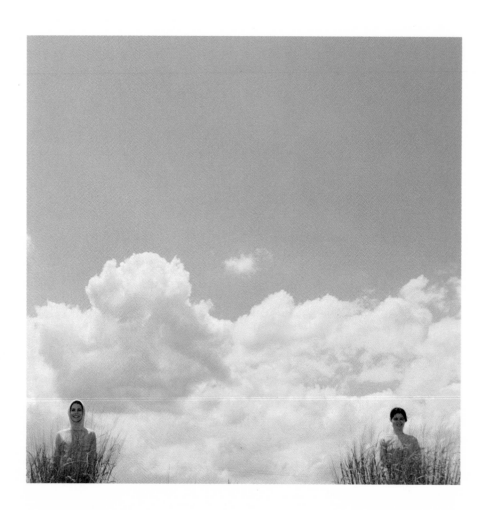

5 **Alex + Laila** 1999, Detour

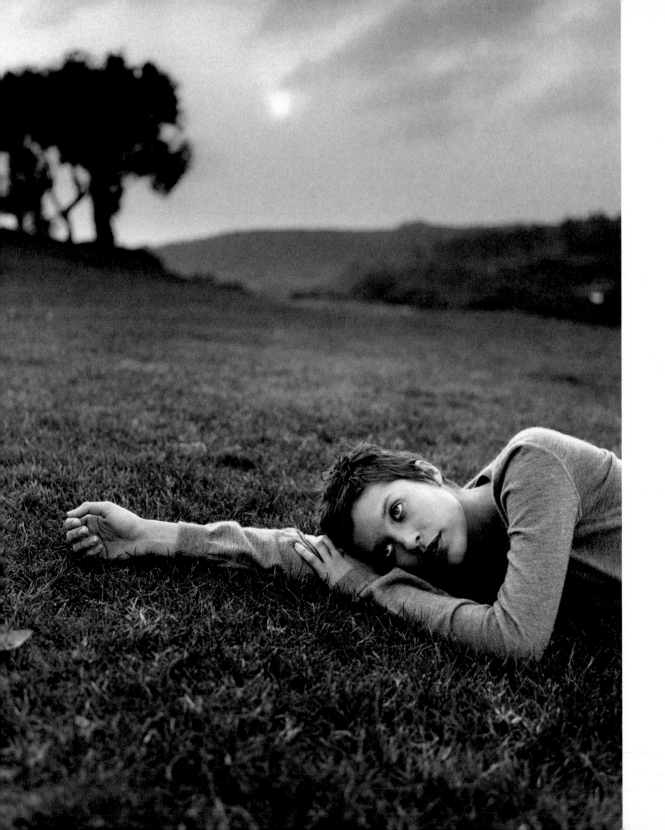

7 **Marcelo Krasilcic** 1998, Spin

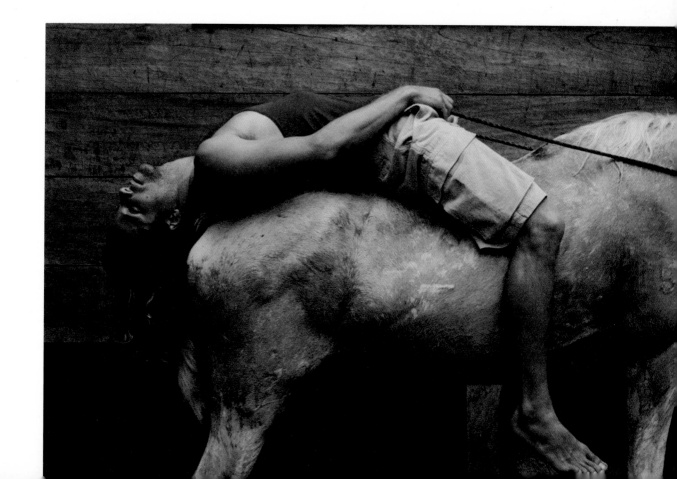

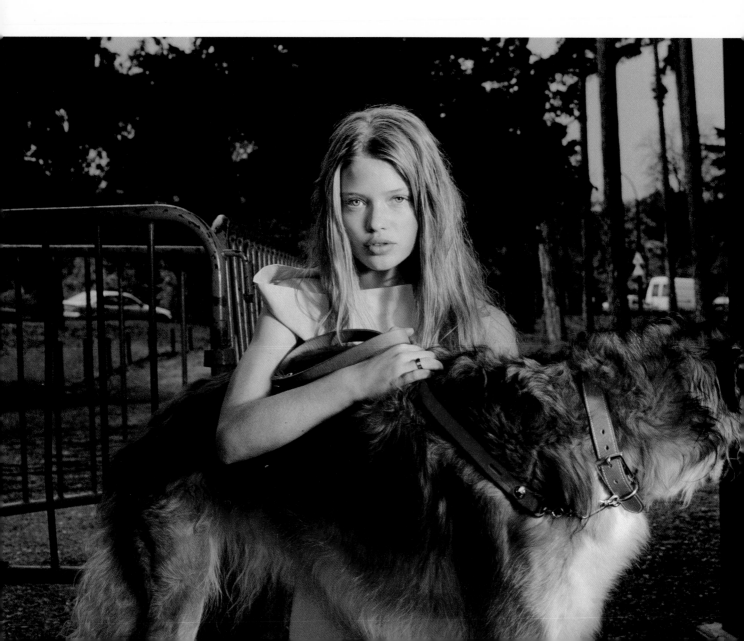

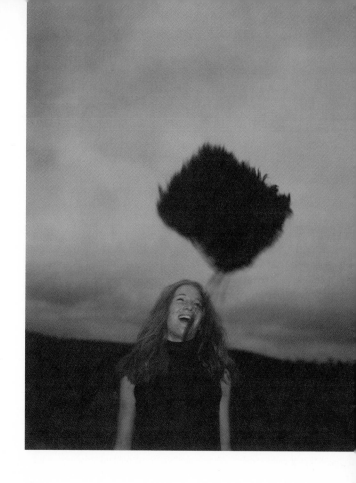

9 **Marcus Tomilson** 1998, Frank

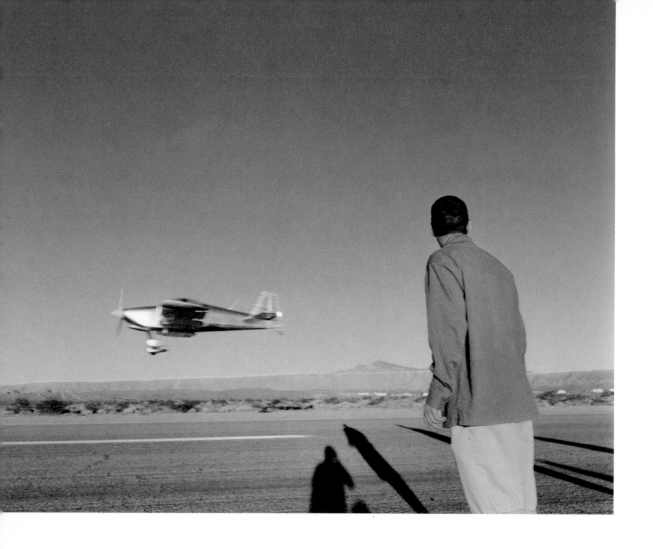

10 **Stefan Ruiz** 1998, Cat/Caterpillar campaign

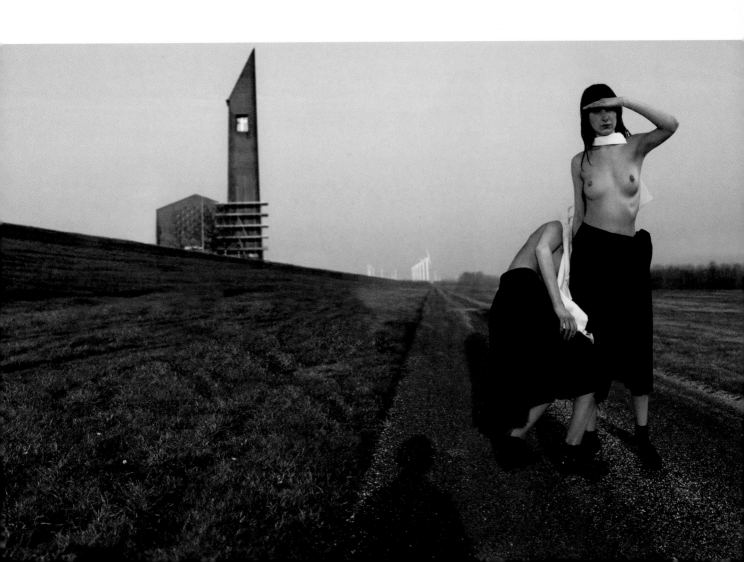

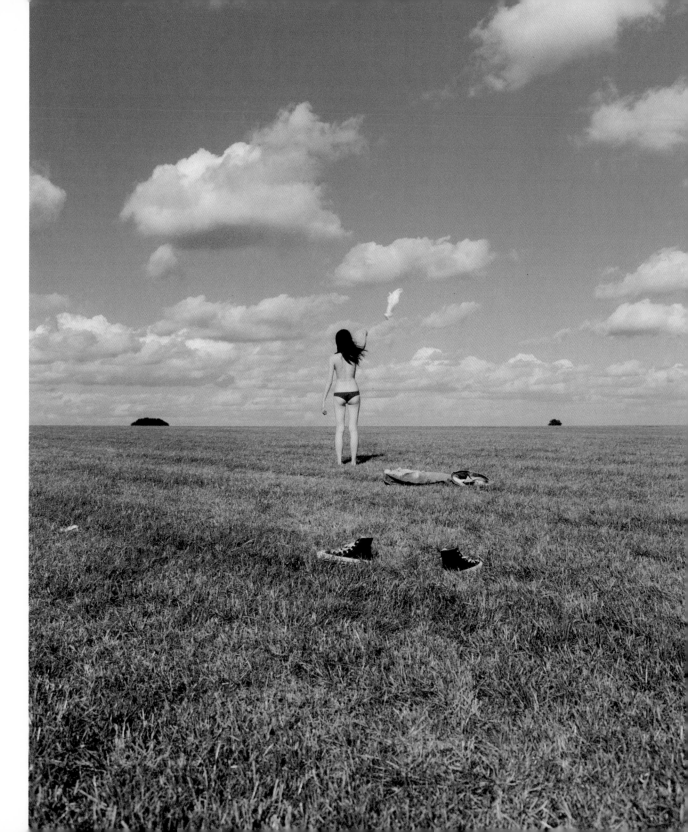

13 **Carmen Freudenthal** 1999, Blvd.

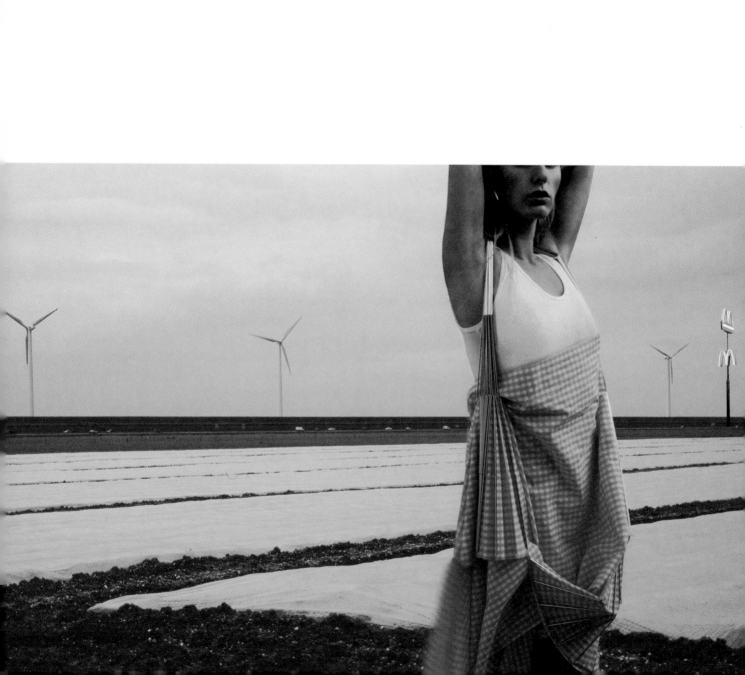

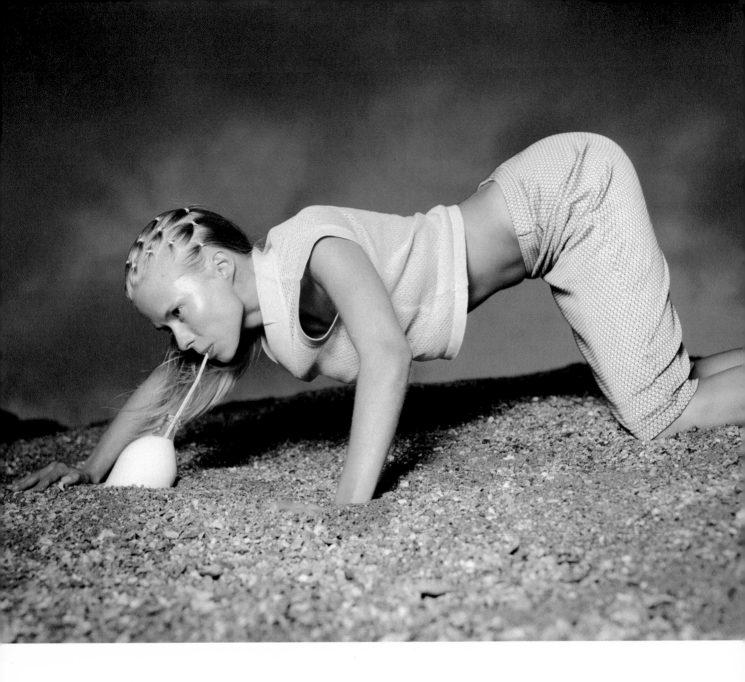

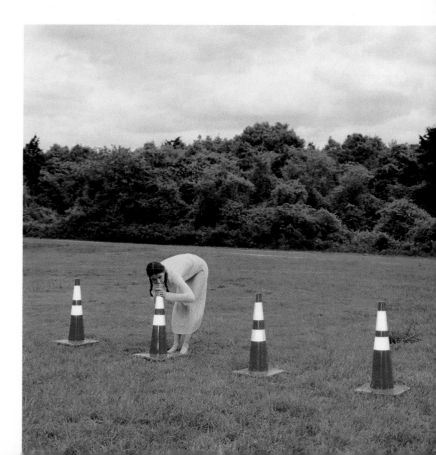

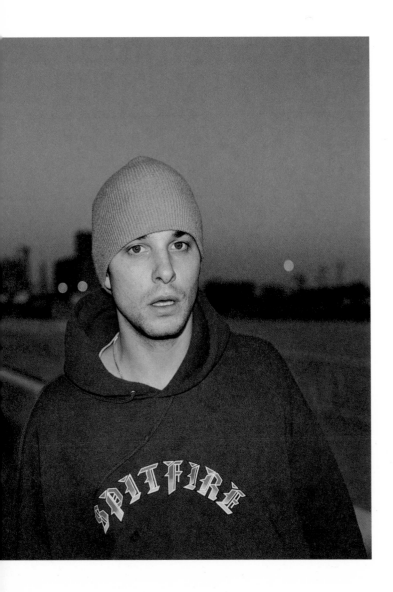

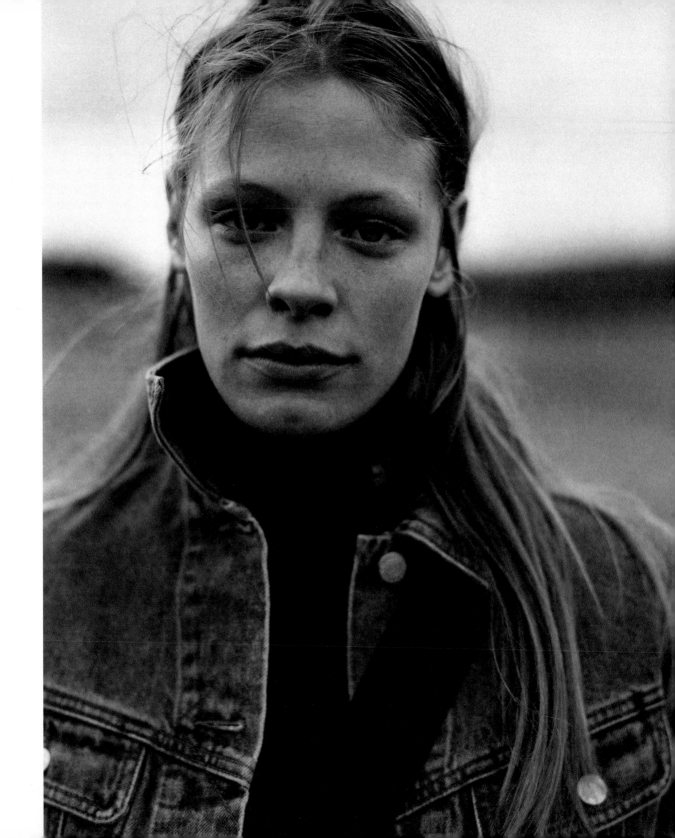

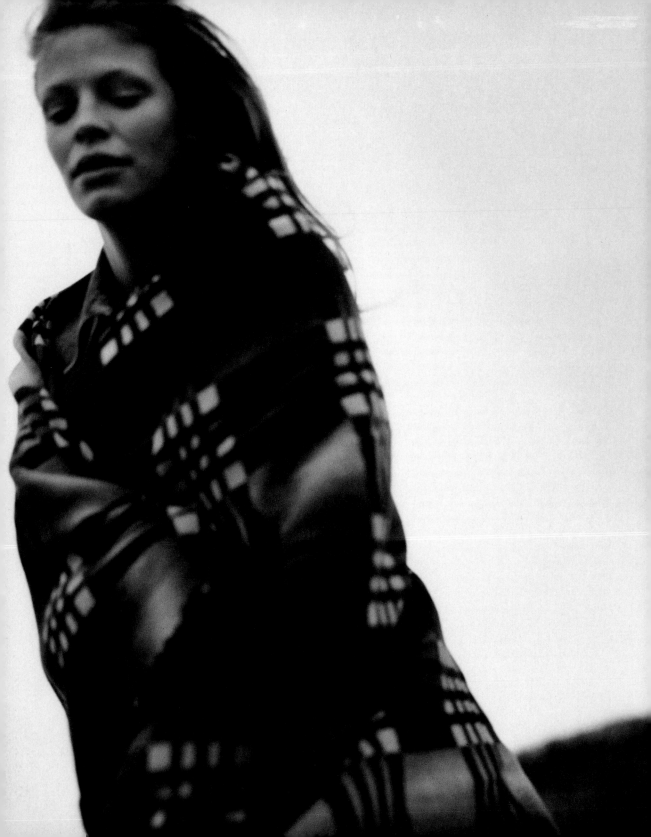

18 **Stewart Shining** 1999, Polo campaign

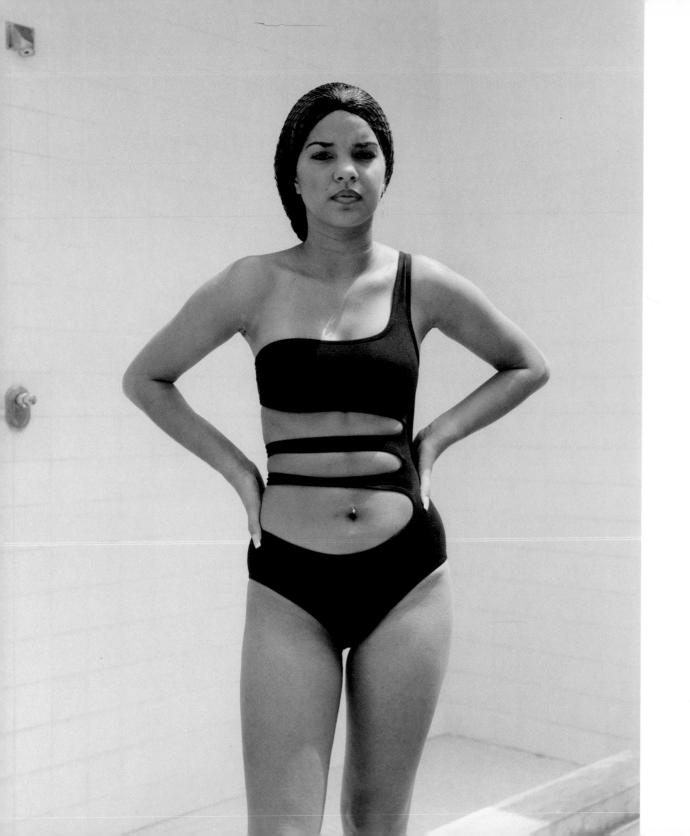

19 **Dana Lixenberg** 1999, Blaze

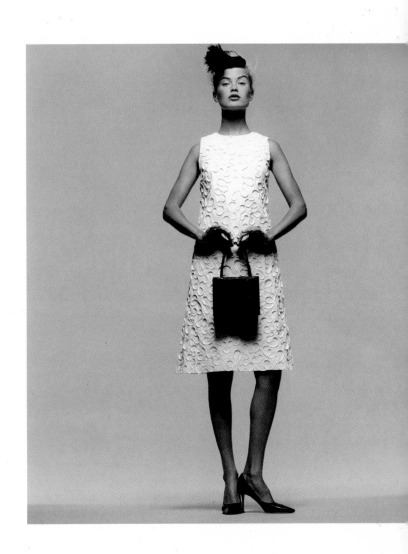

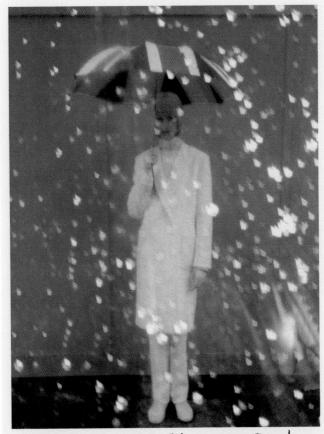

NEVER PHOTOGRAPH IN THE RAIN

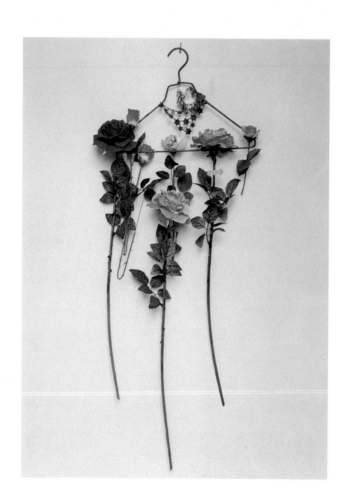

23 **Tim Walker** 1999, Italian Vogue

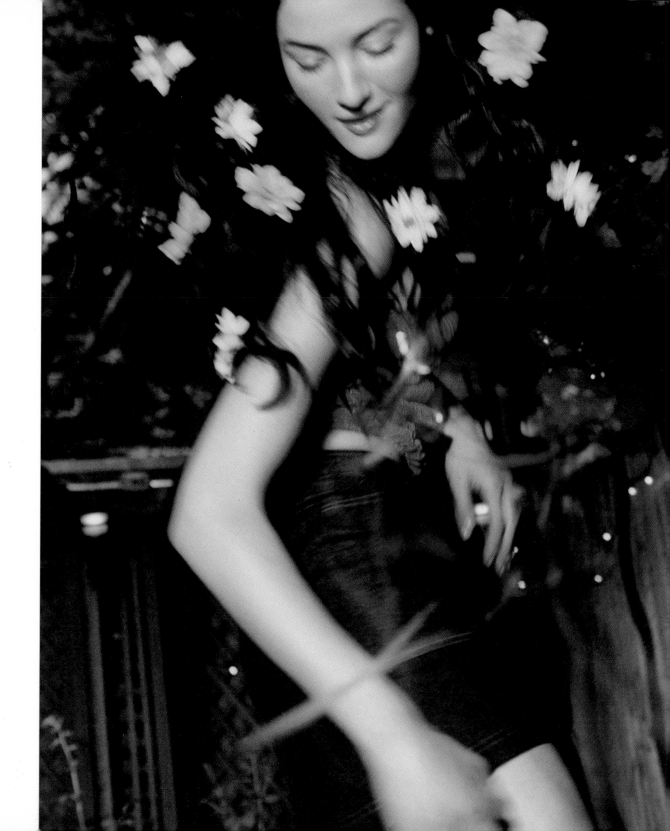

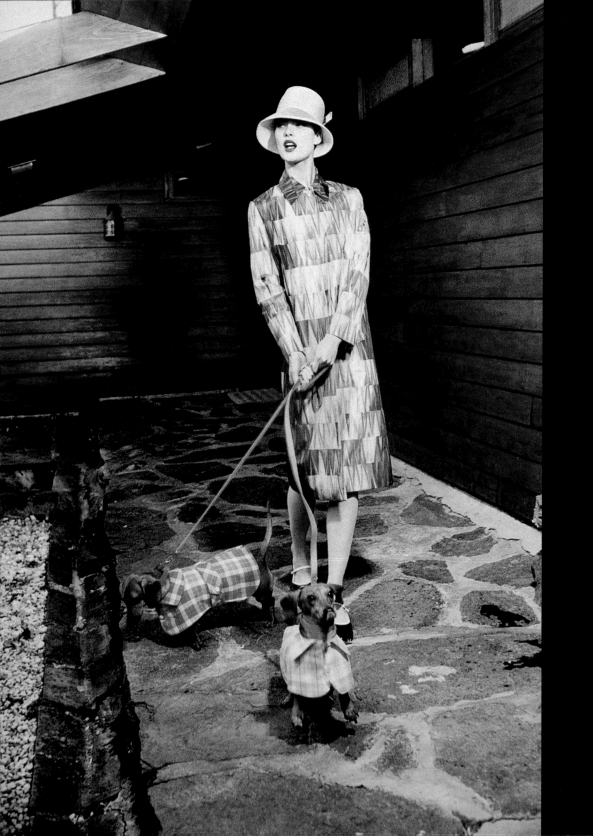

25 Ellen von Unwerth, 1999 Italian Vogue

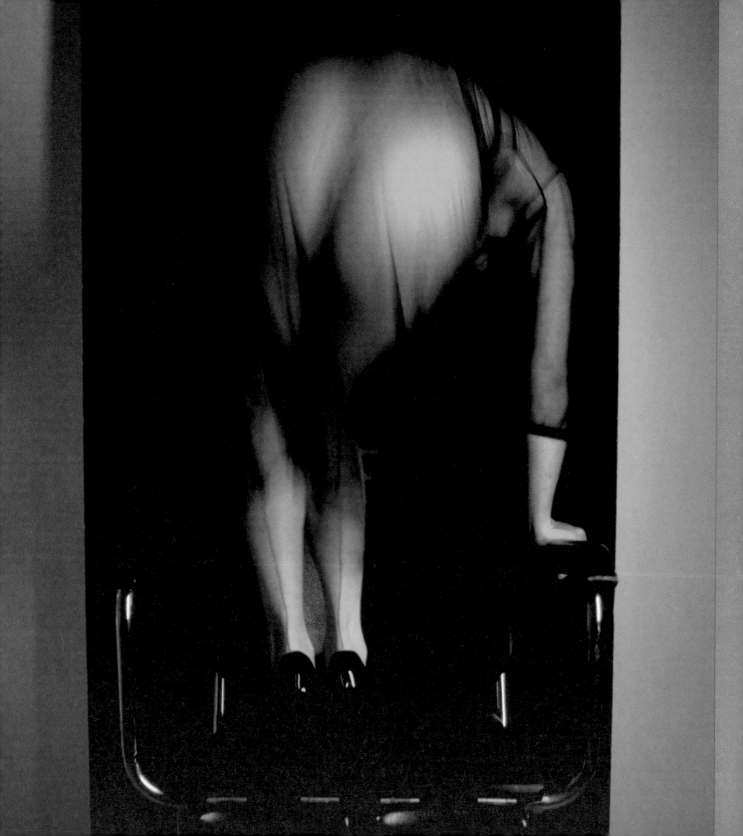

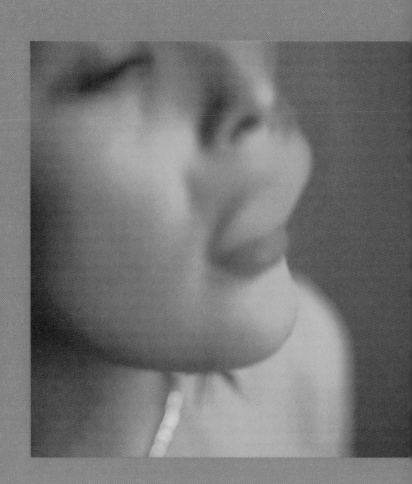

27 **Edel Verzijl** 1999, 2wice 28 **Edel Verzijl** 1999, 2wice

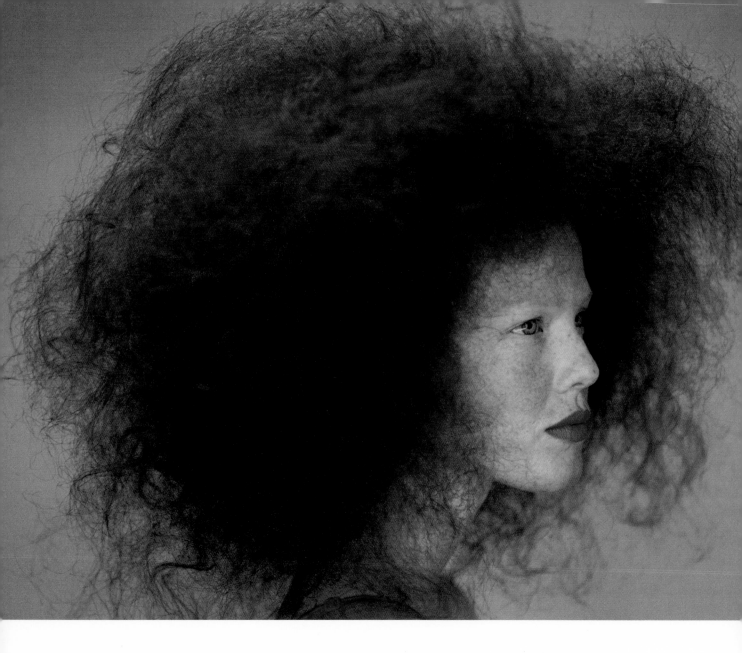

29 **Cleo Sullivan** 1999, Italian Amica

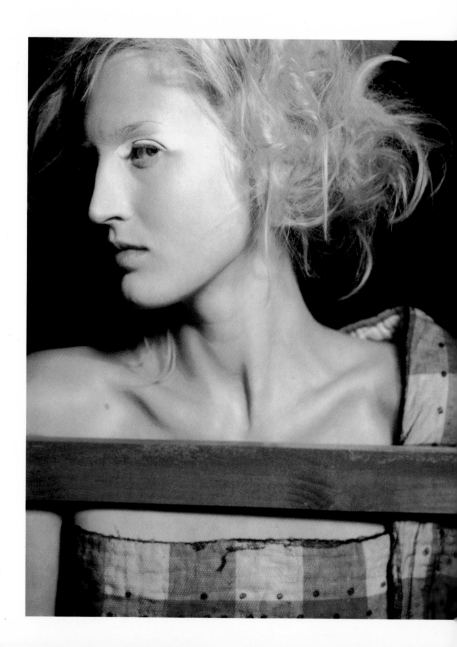

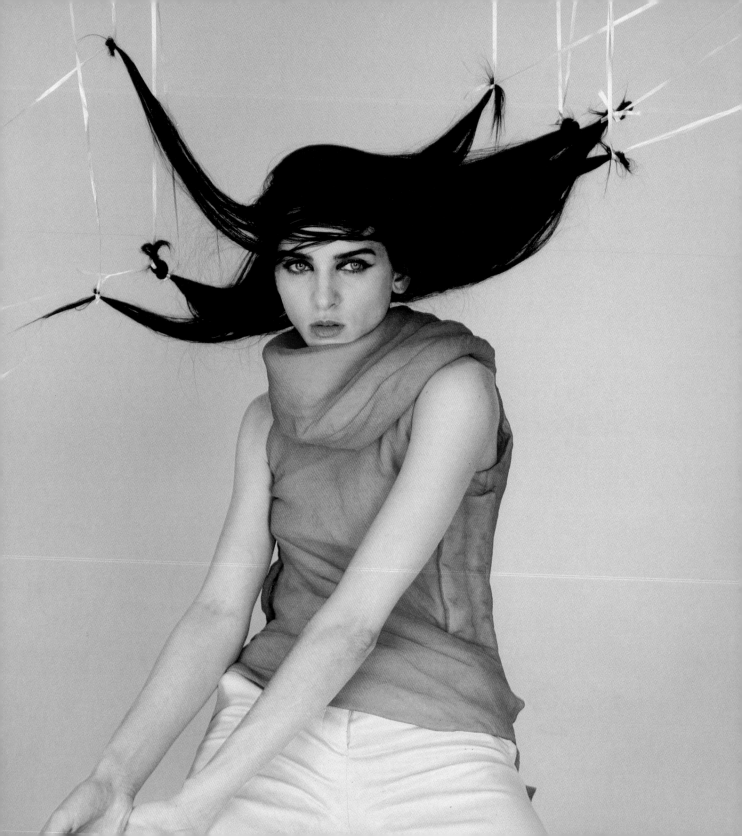

31 **Tiziano Magni** 1999, Mirabella

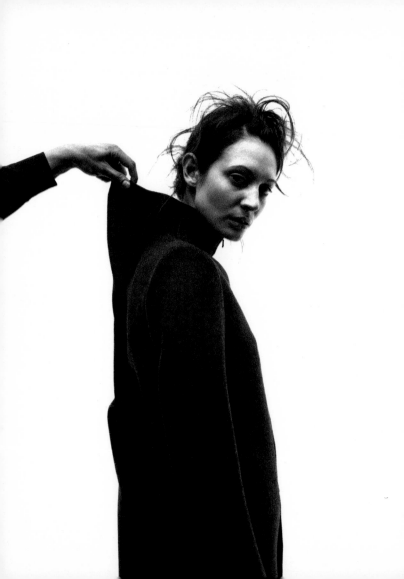

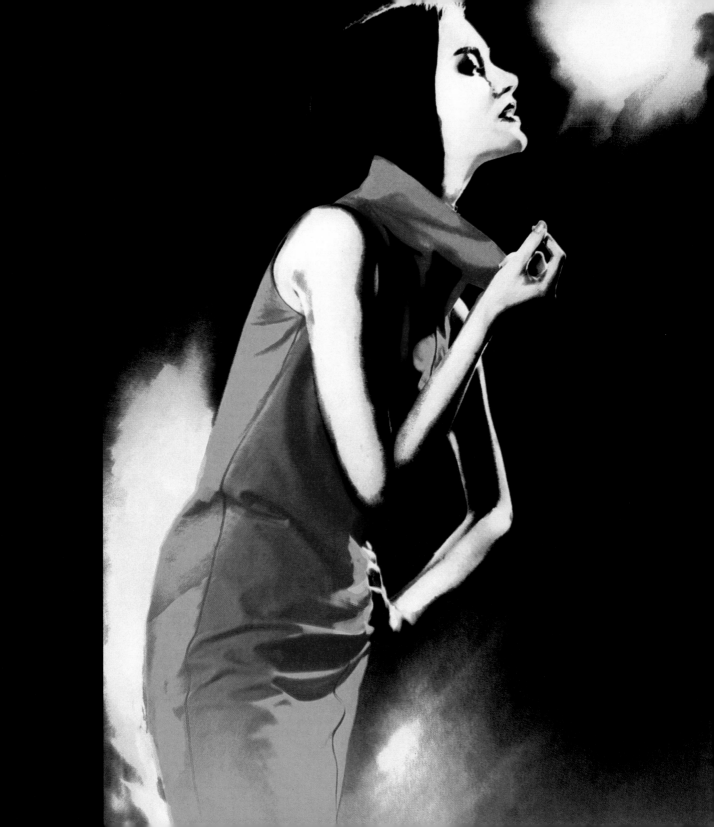

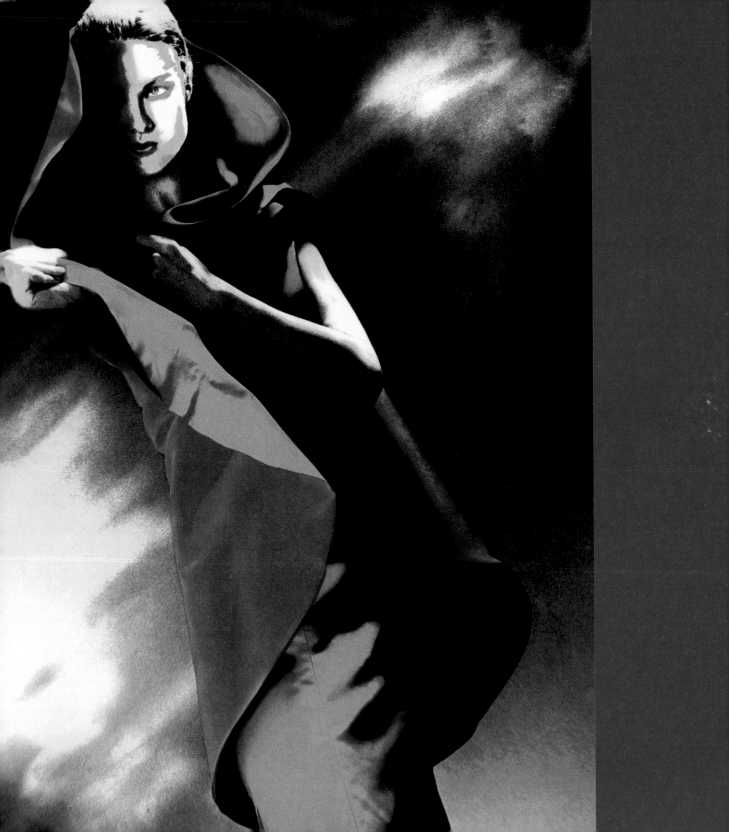

34 **Lillian Bassman** 1999, Detour

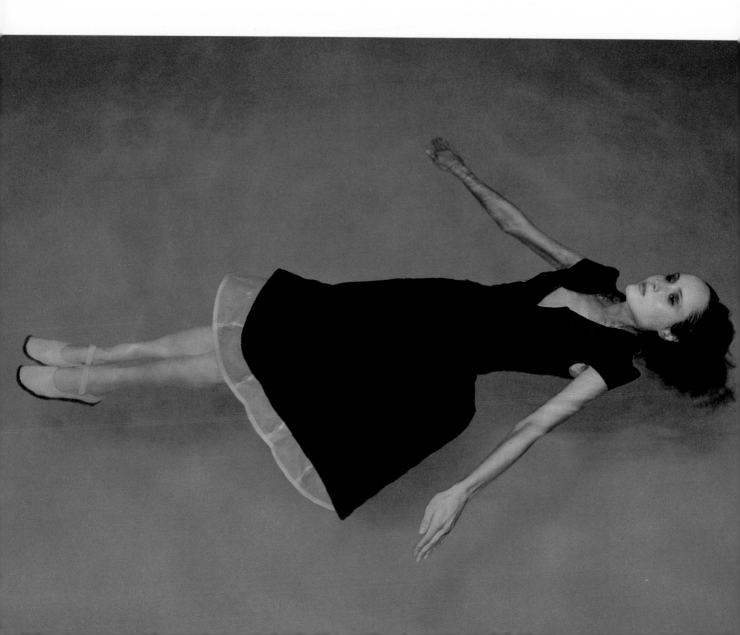

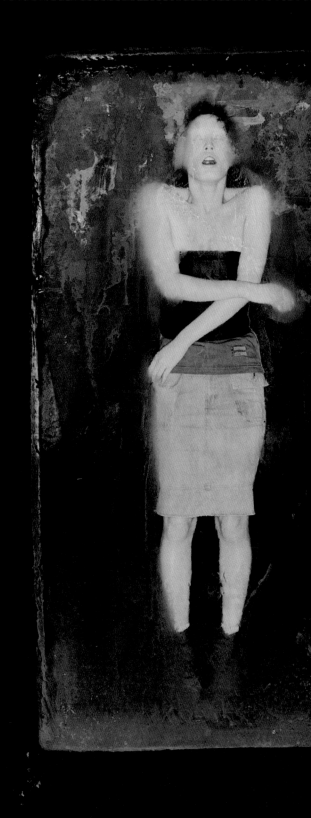

Rankin 1998, Diesel campaign

Rankin 1998, Diesel campaign

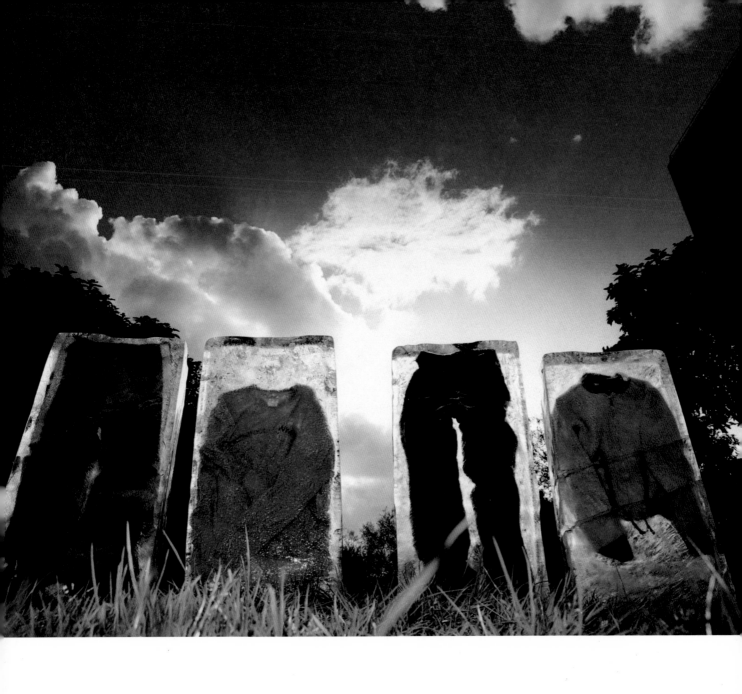

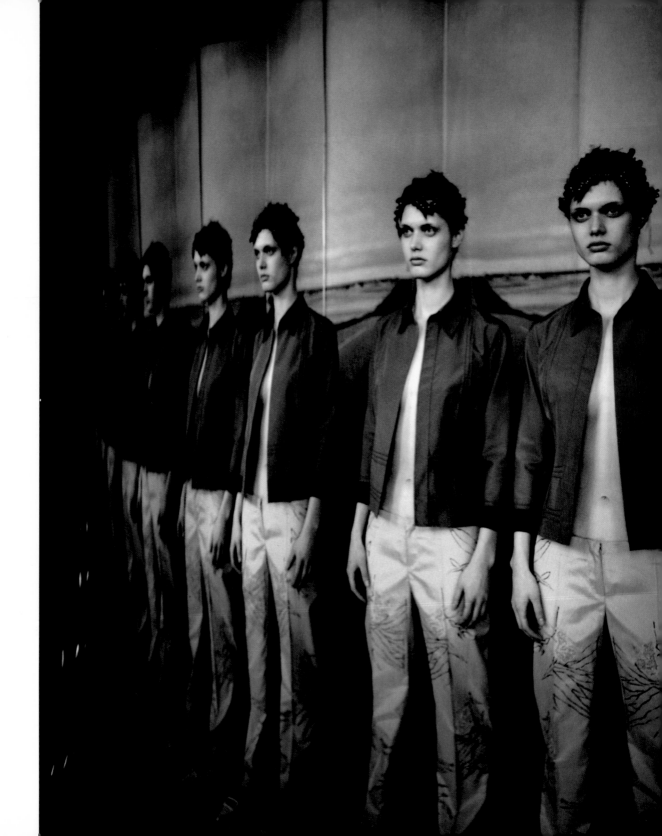

Paolo Roversi 1999, Alberta Ferretti campaign

Dah Len 1999, Detour (overleaf)

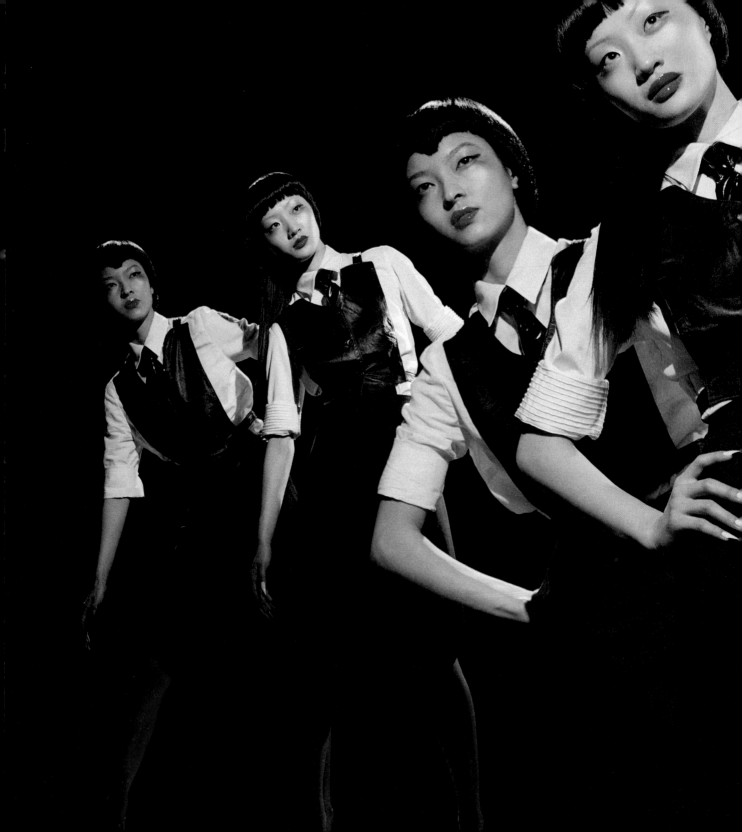

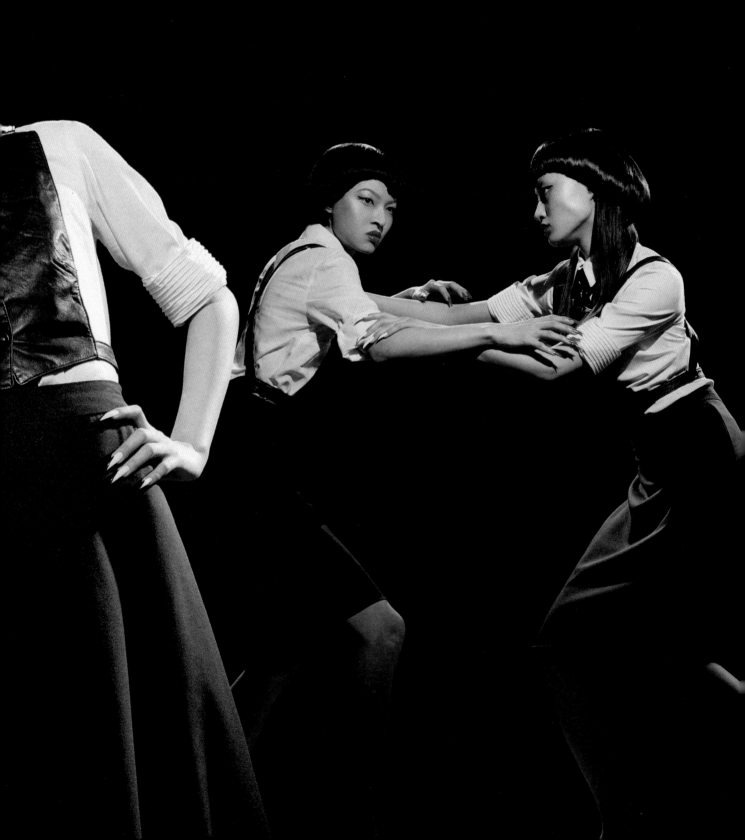

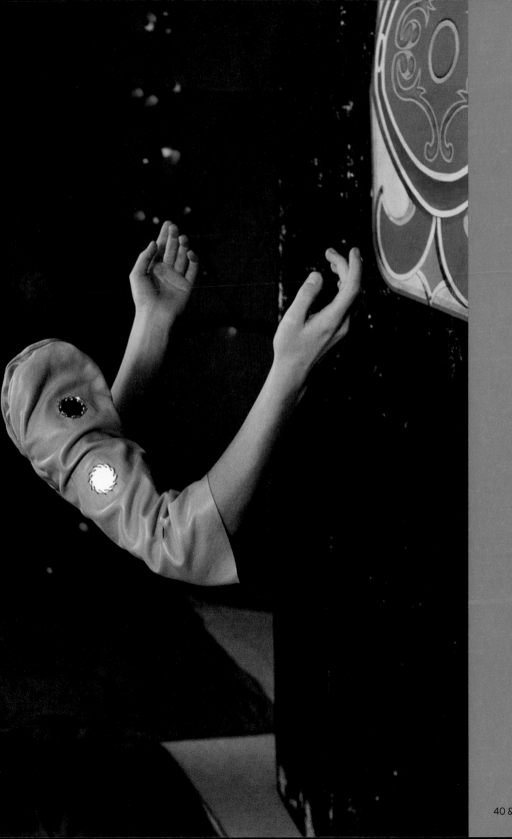

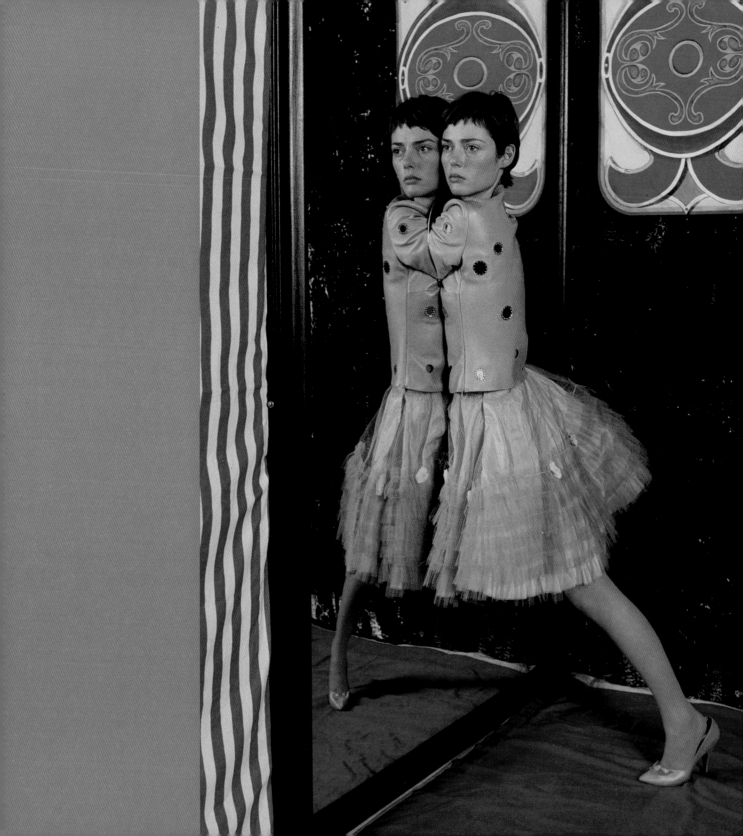

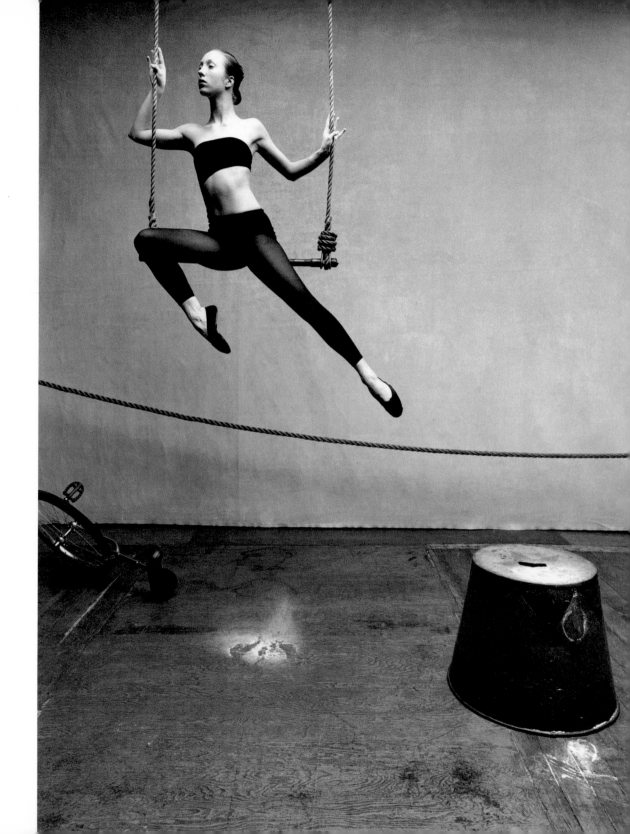

Christian Witkin 1999, Harper's Bazaar

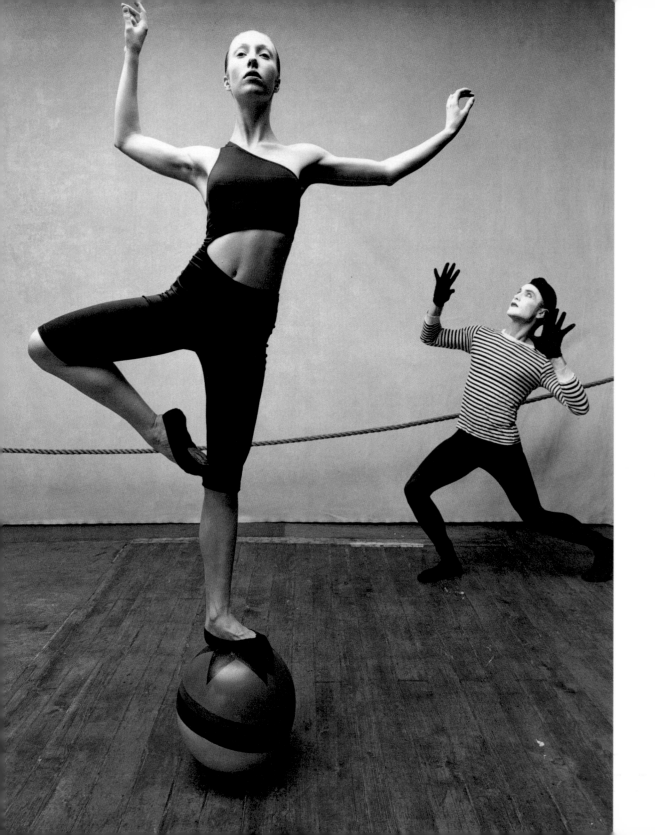

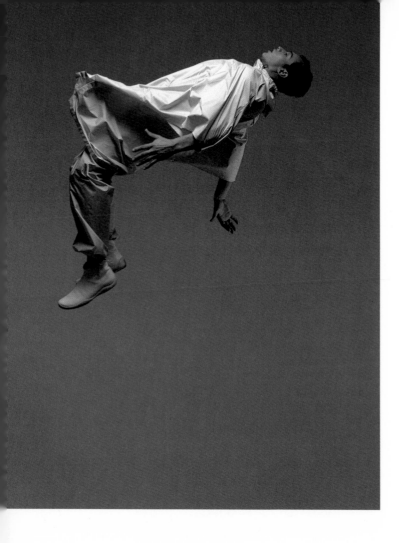

43 **Tom van Heel** 1998, Squeeze

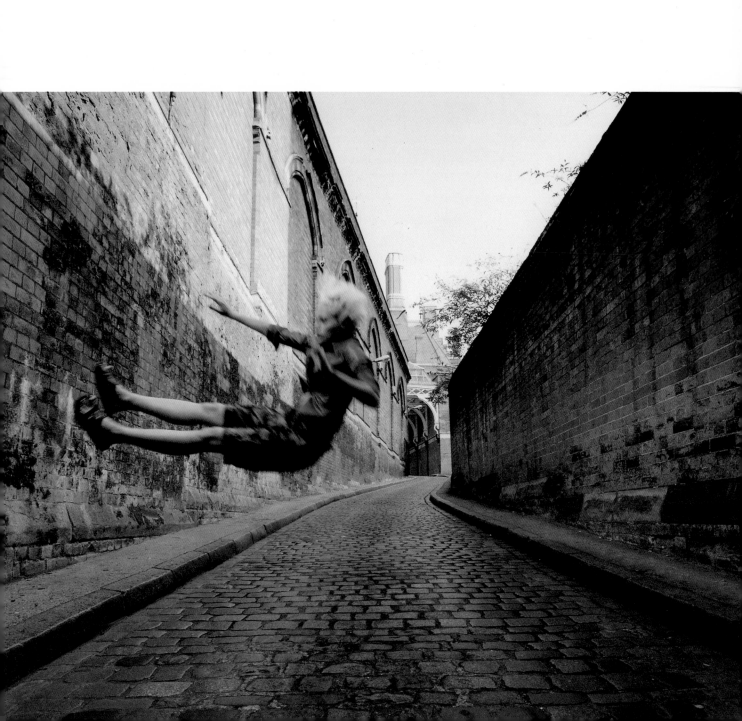

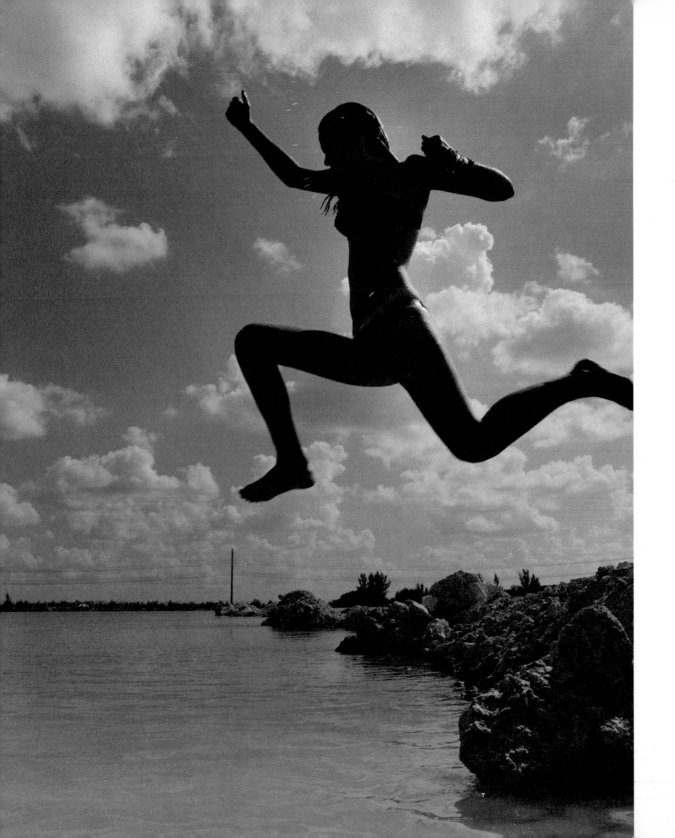

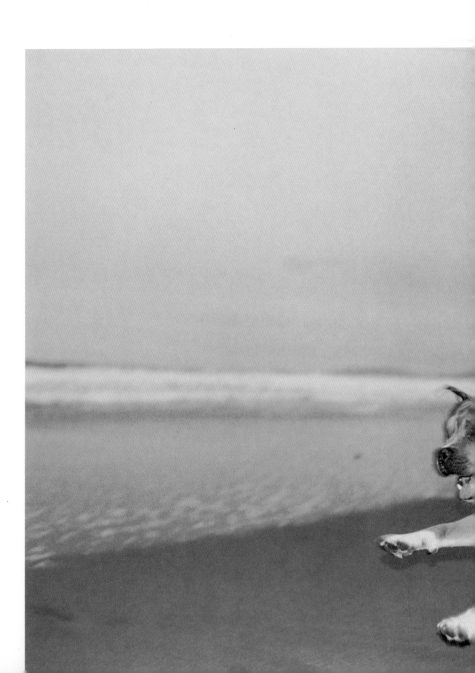

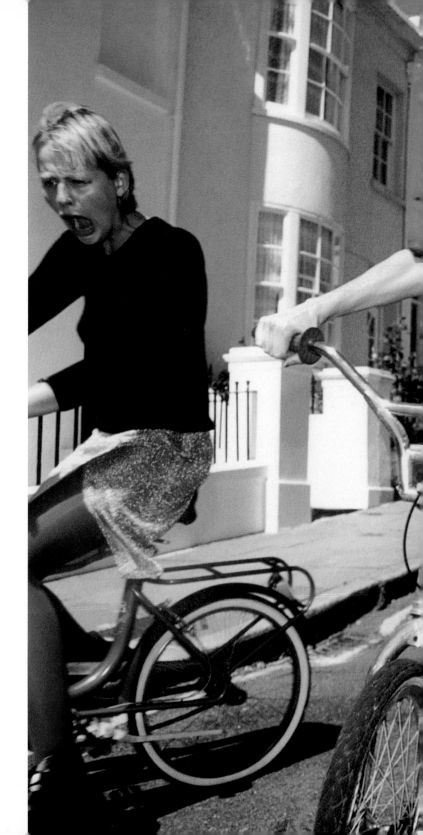

Elaine Constantine 1997, The Face

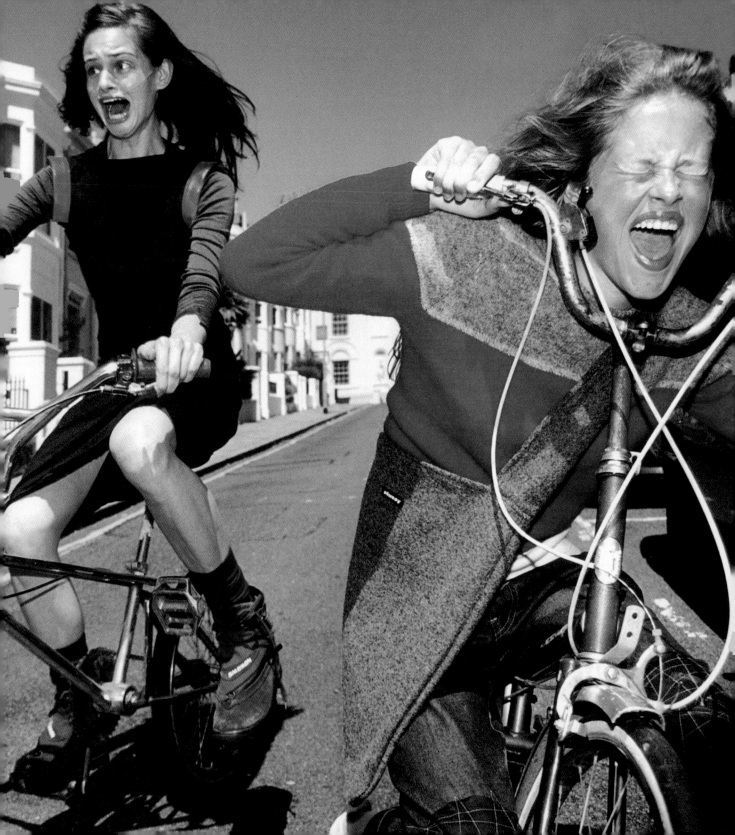

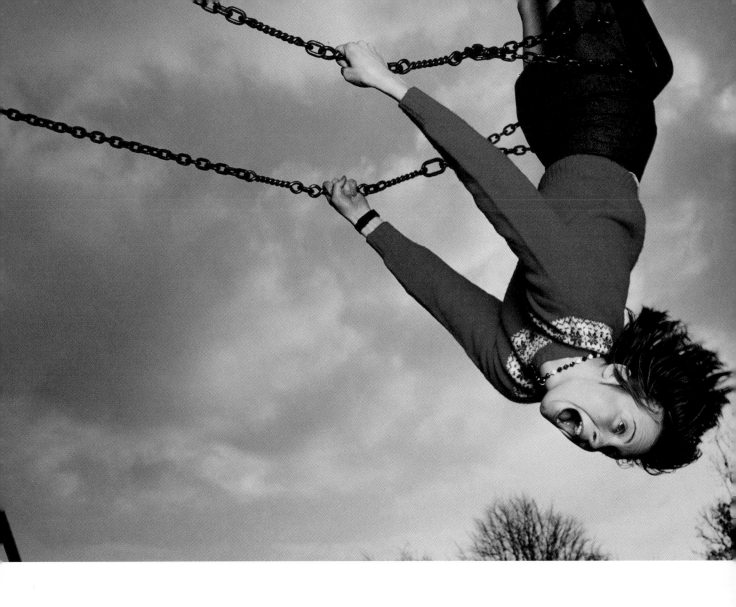

48 **Elaine Constantine** 1999, The Face

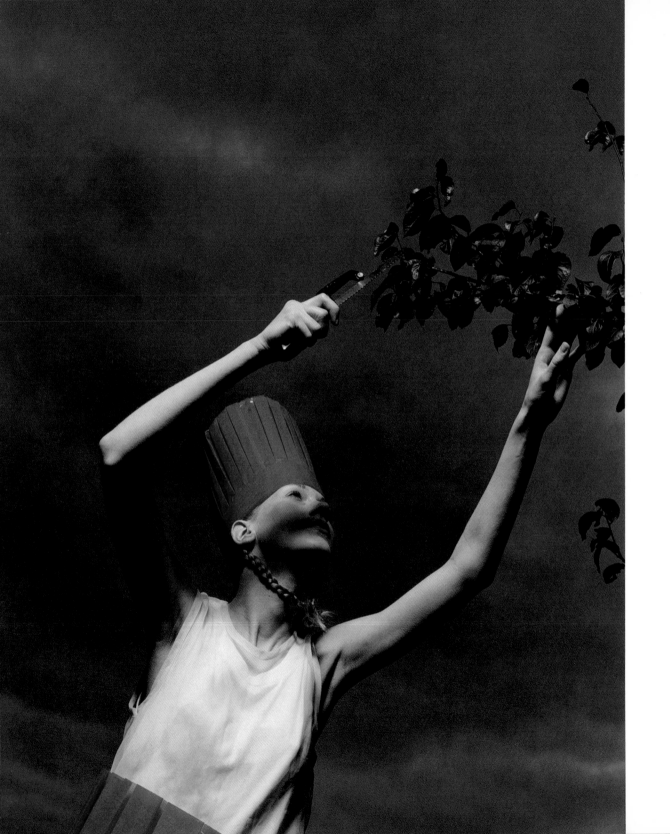

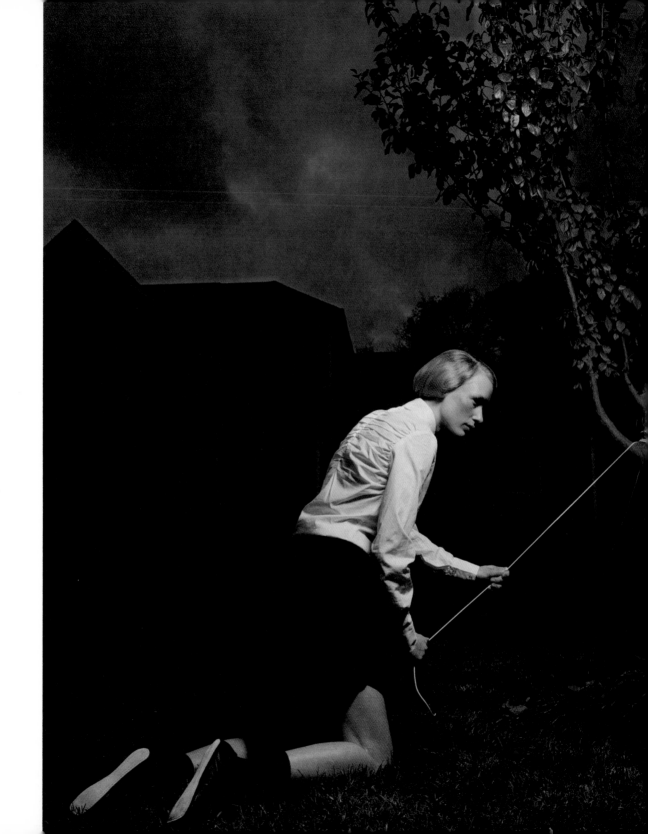

Jelle Wagenaar 1998, unpublished

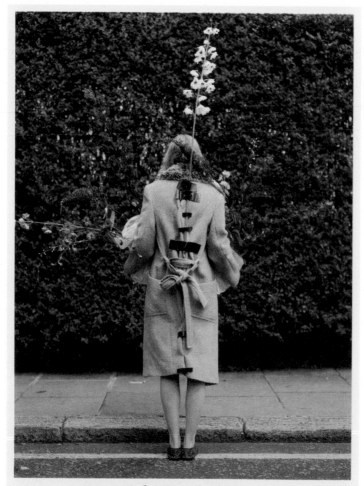

FROM THE SUBJECTS' FACE

51 **Tim Walker** 1998, Italian Vogue

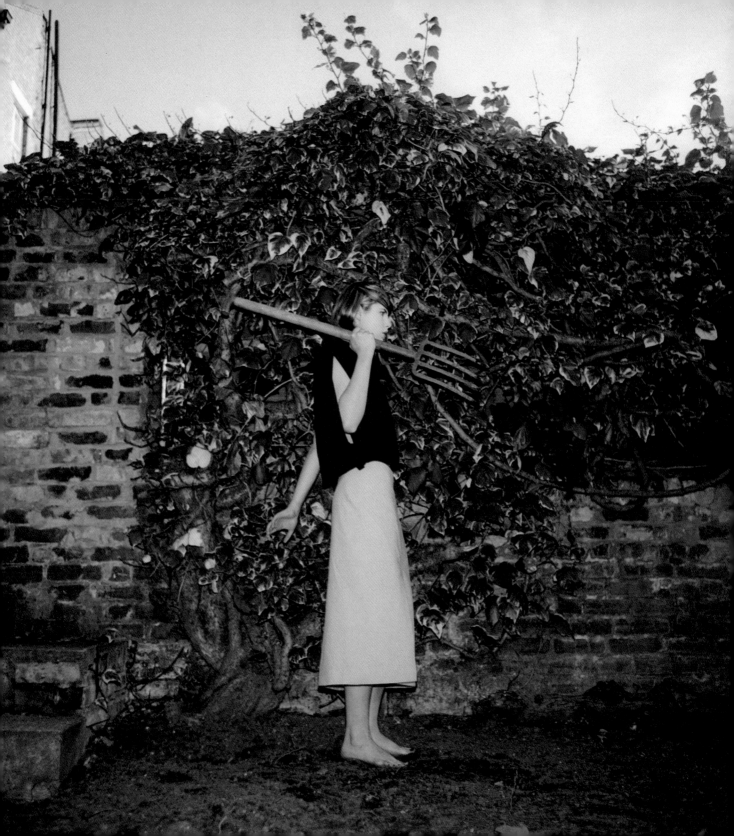

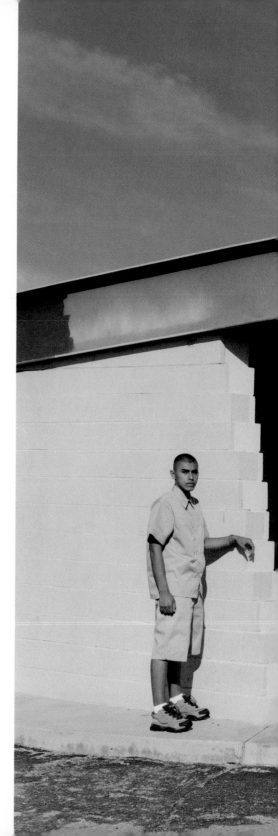

53 **Stefan Ruiz** 1998, Cat/Caterpillar campaign

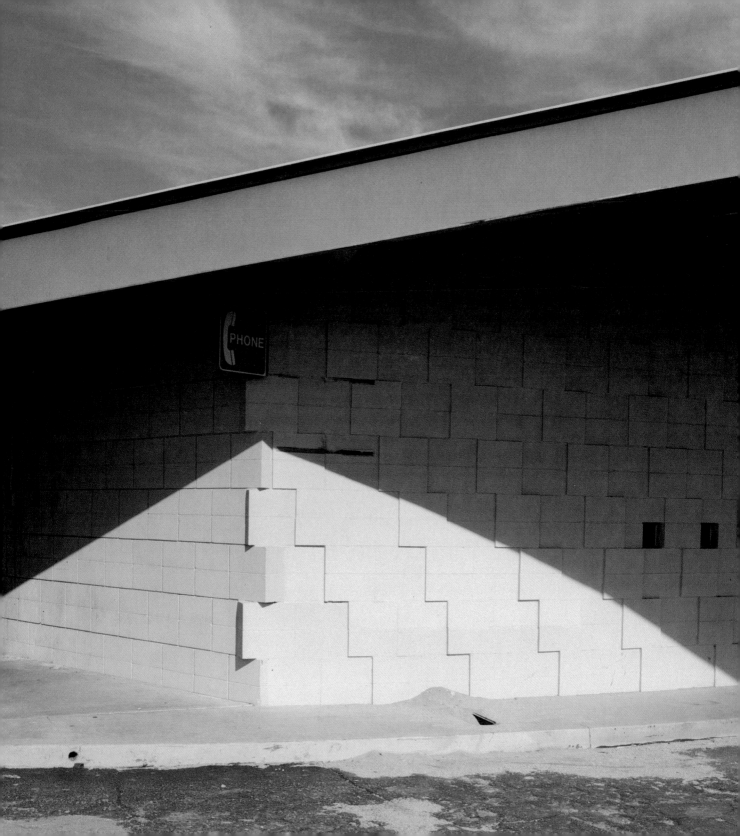

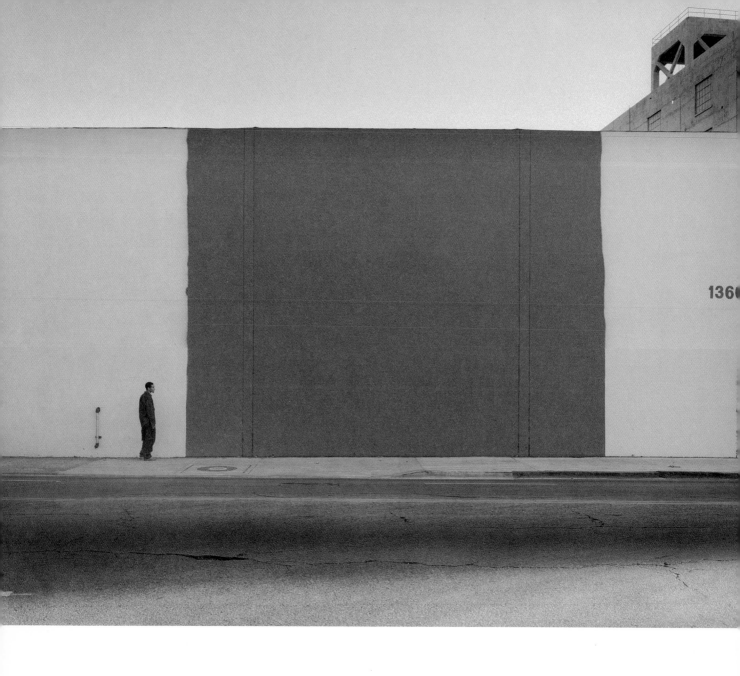

54 **Stefan Ruiz** 1998, Cat/Caterpillar campaign

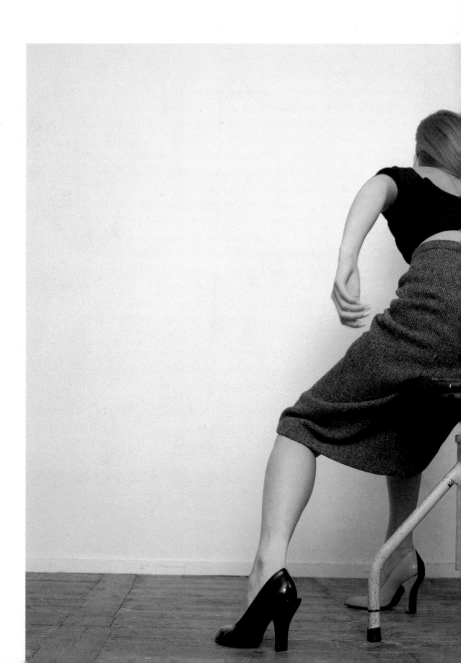

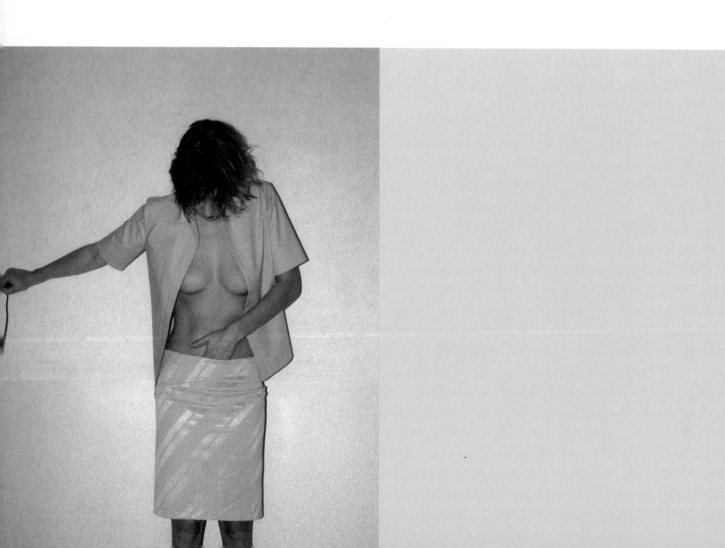

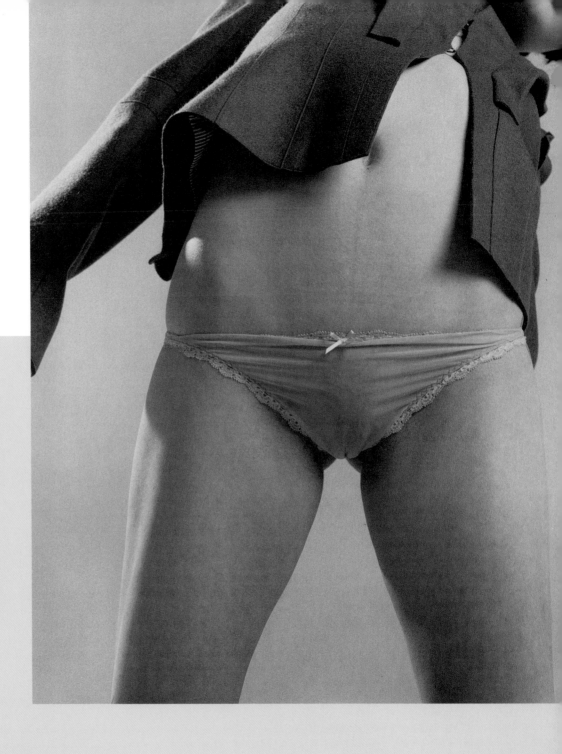

57 **Dana Menussi** 1999, Spanish Harper's Bazaar, unpublished

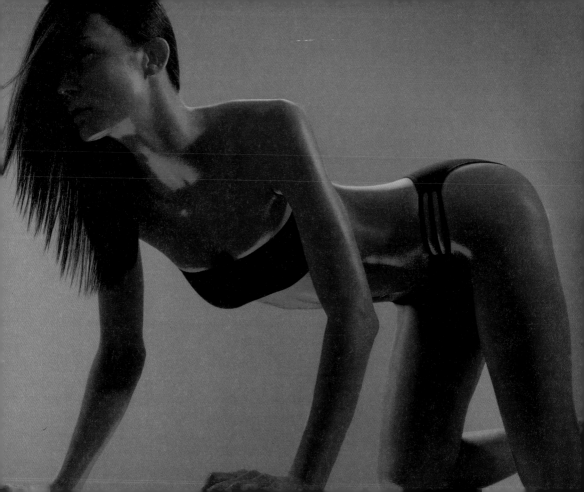

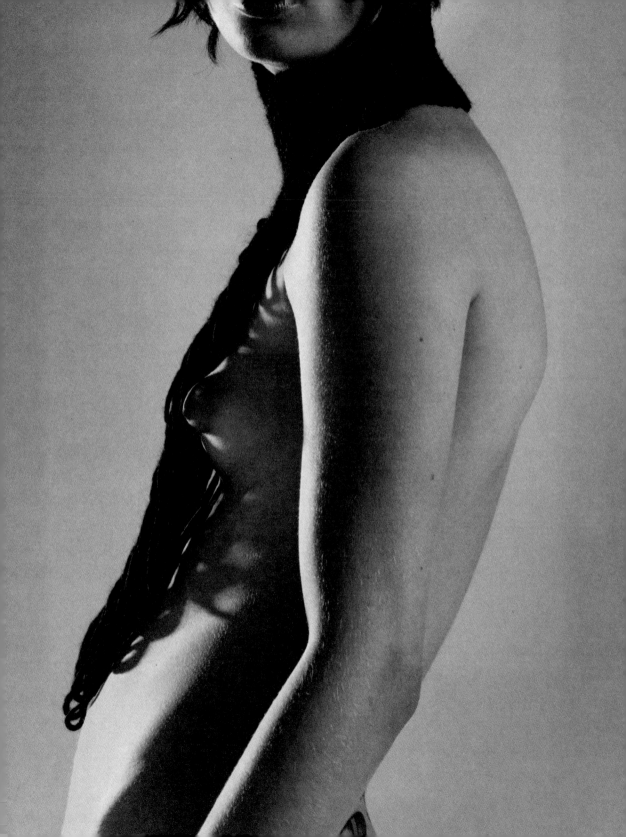

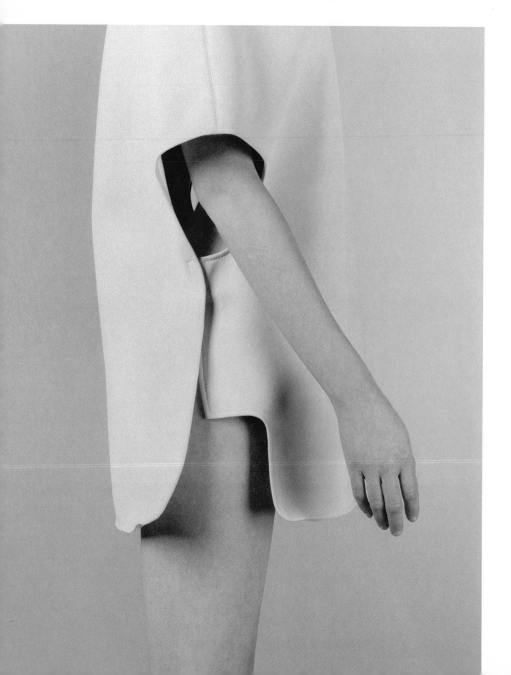

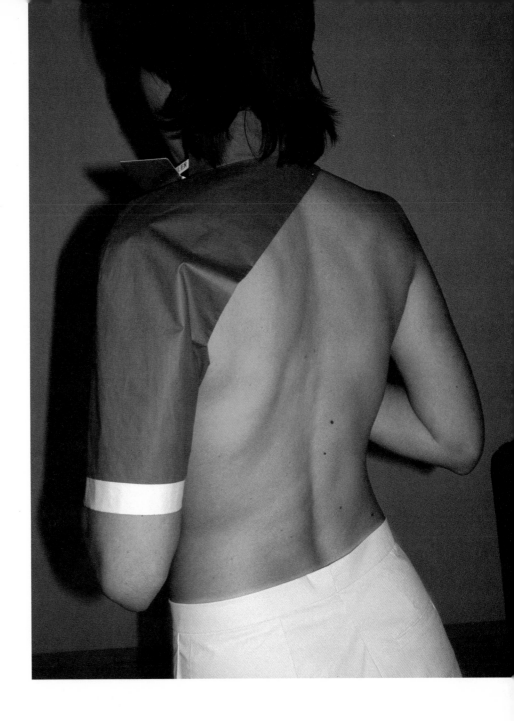

61 **Johanna Martien Mulder** 1999, Purple

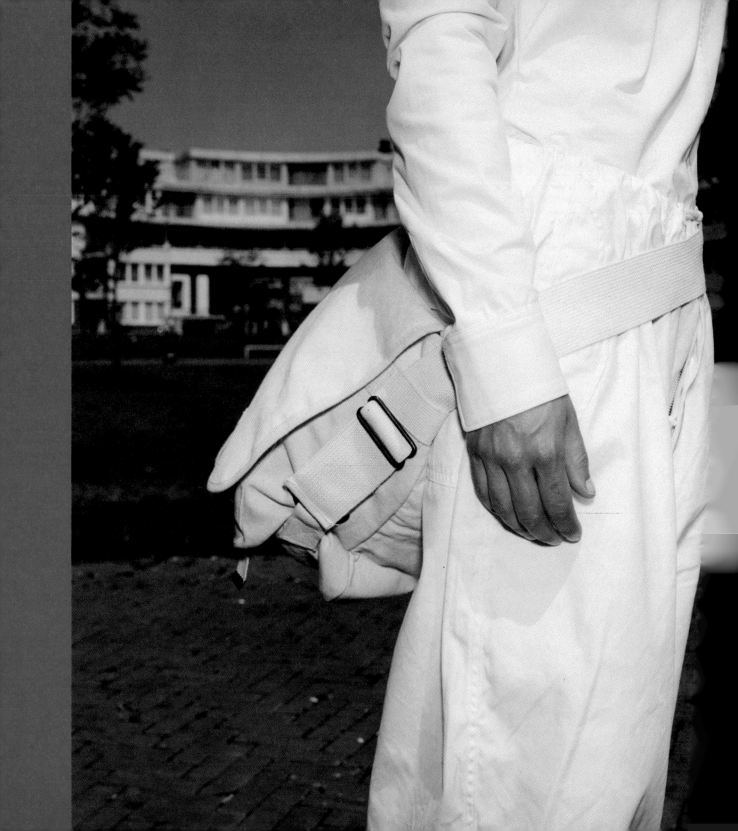

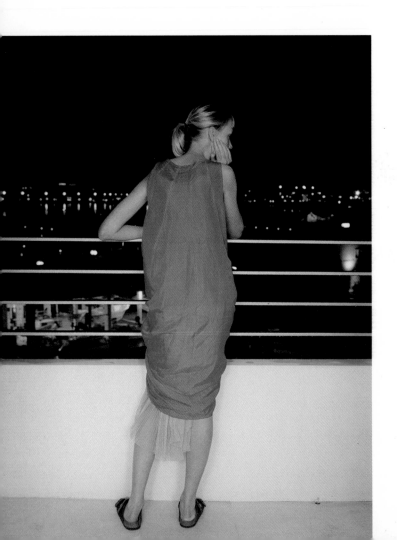

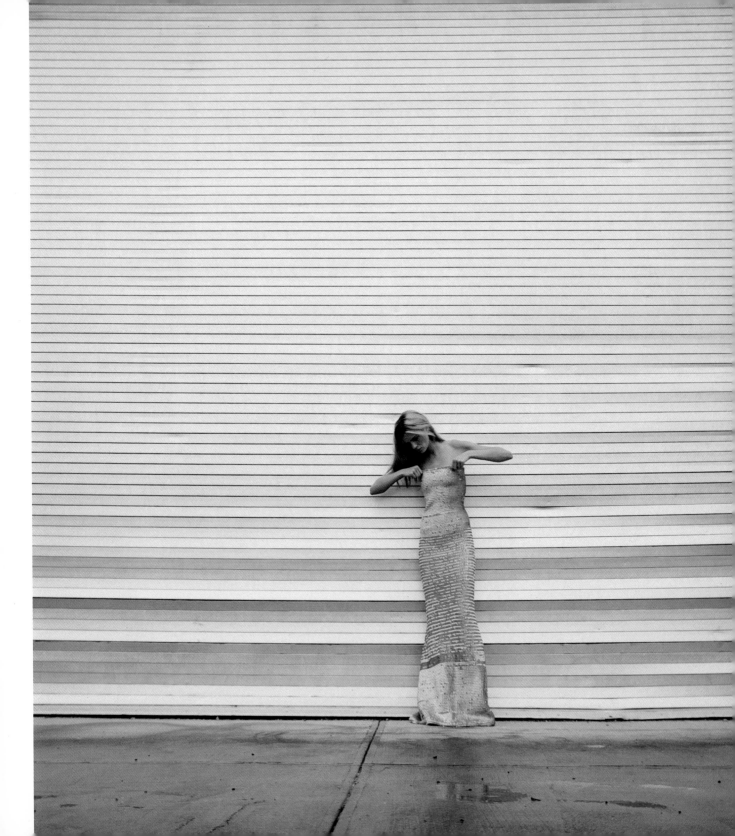

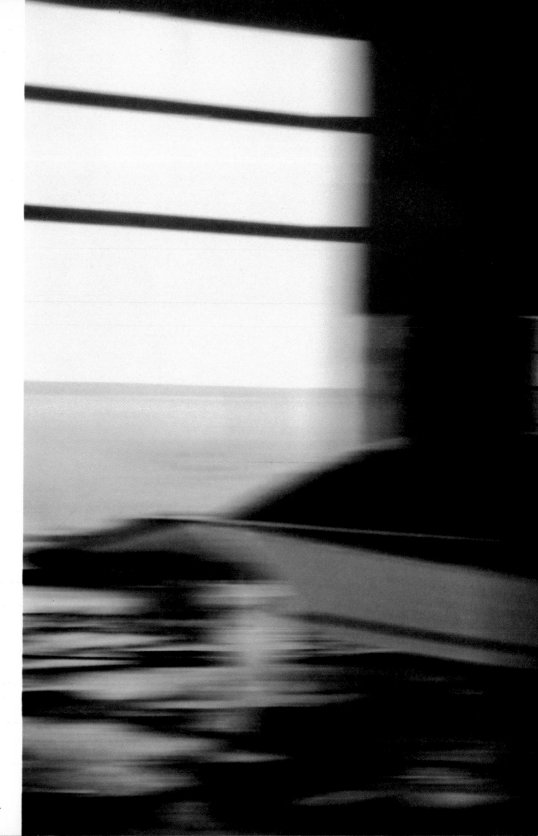

65 **Stephane Sednaoui** 1998, Detour

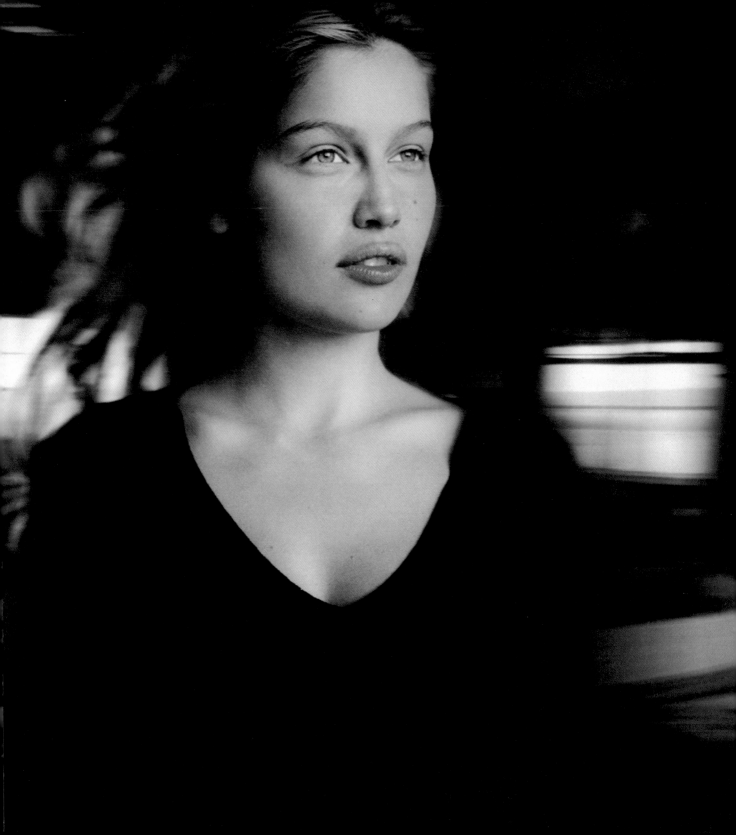

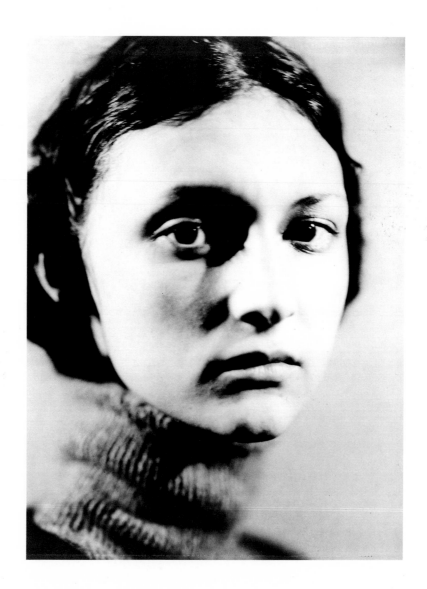

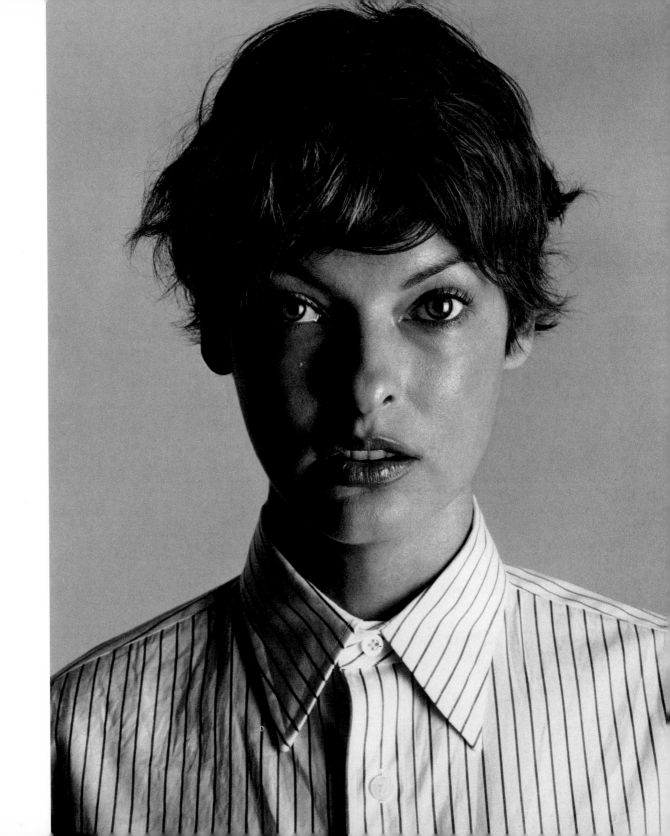

Kent Baker 1998, Guardian

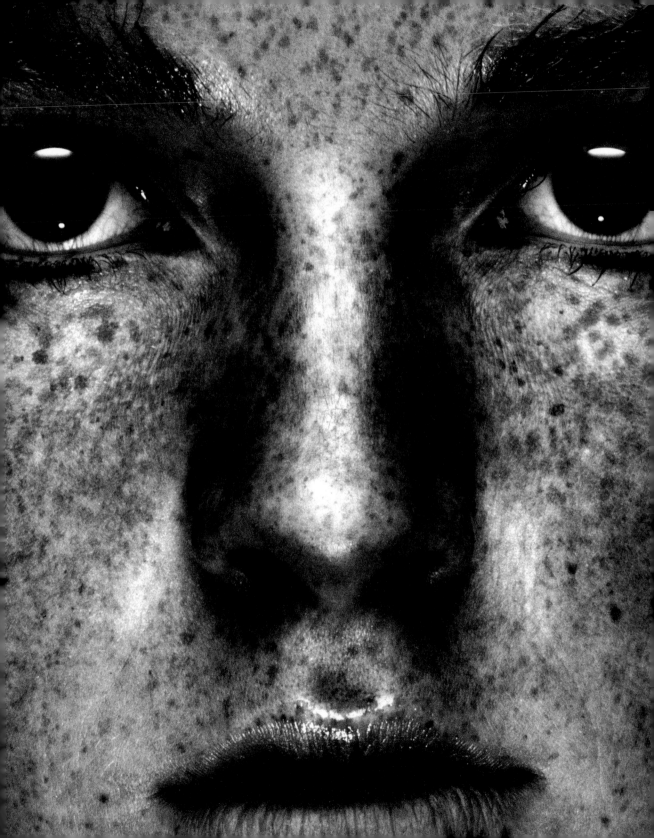

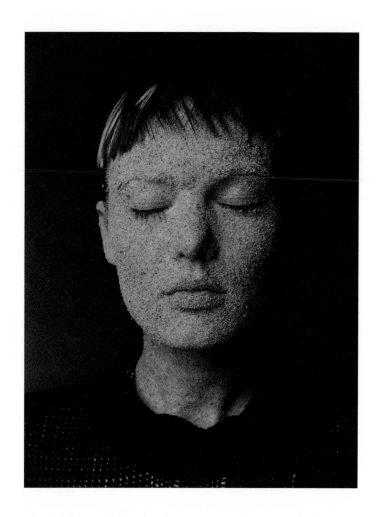

69 & 70 **Rankin** 1998, Dazed & Confused

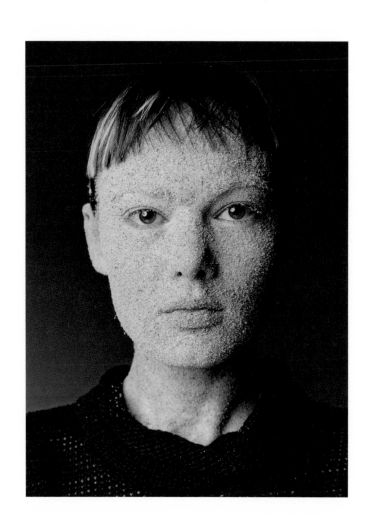

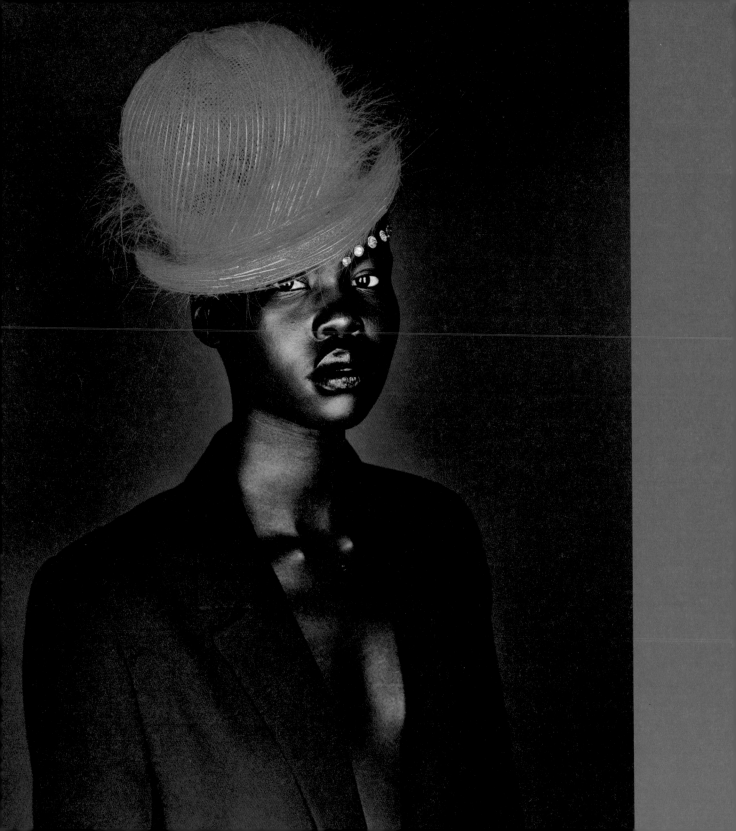

Michael Thompson 1999, W

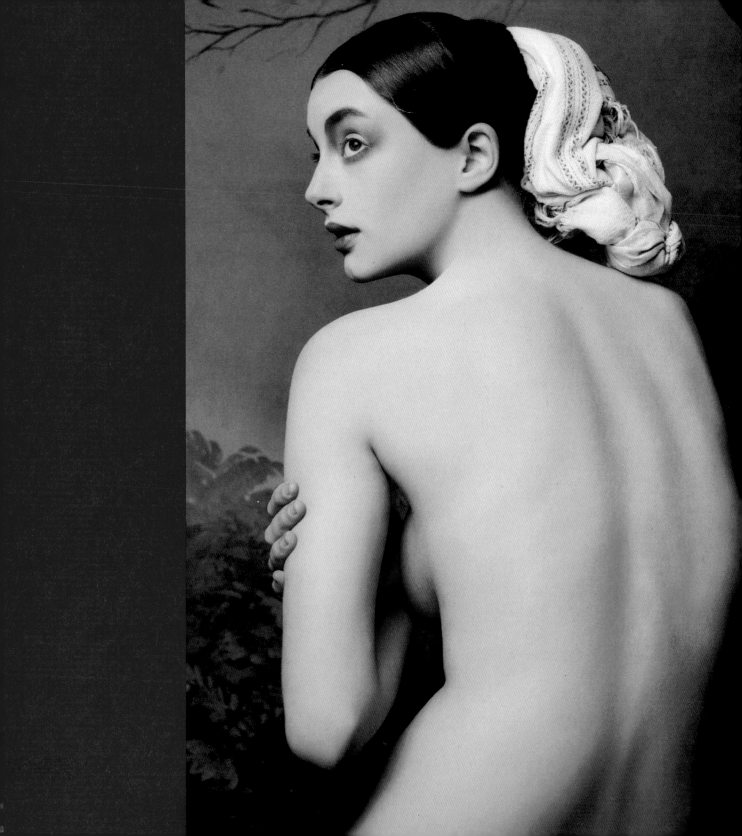

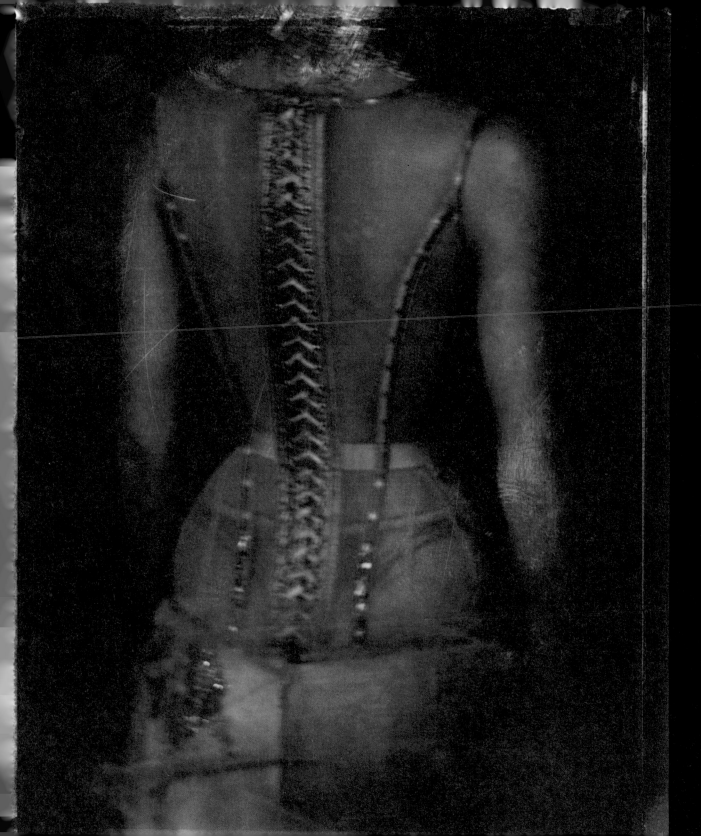

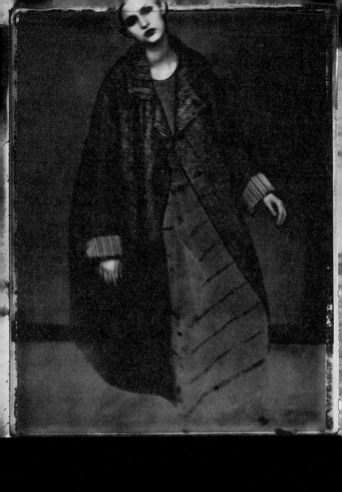

Sarah Moon 1997 Issey Miyake campaign

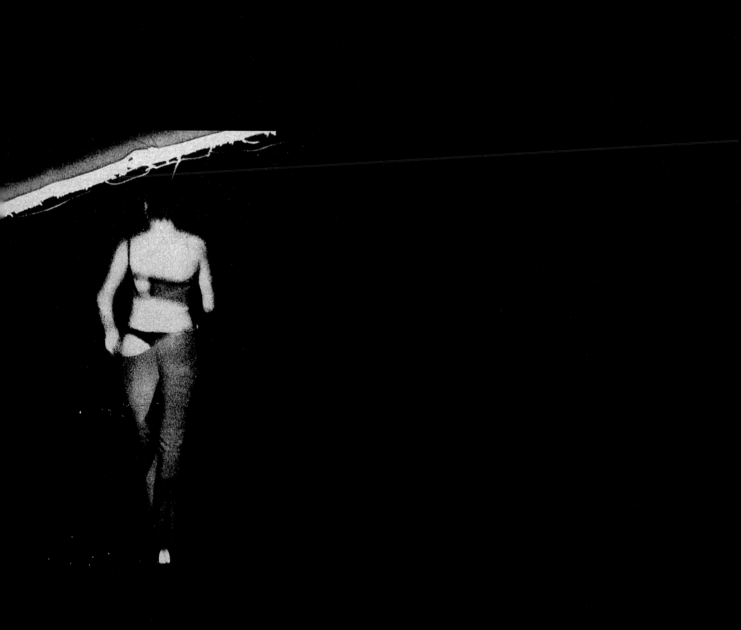

Umberto Stefanelli 1999

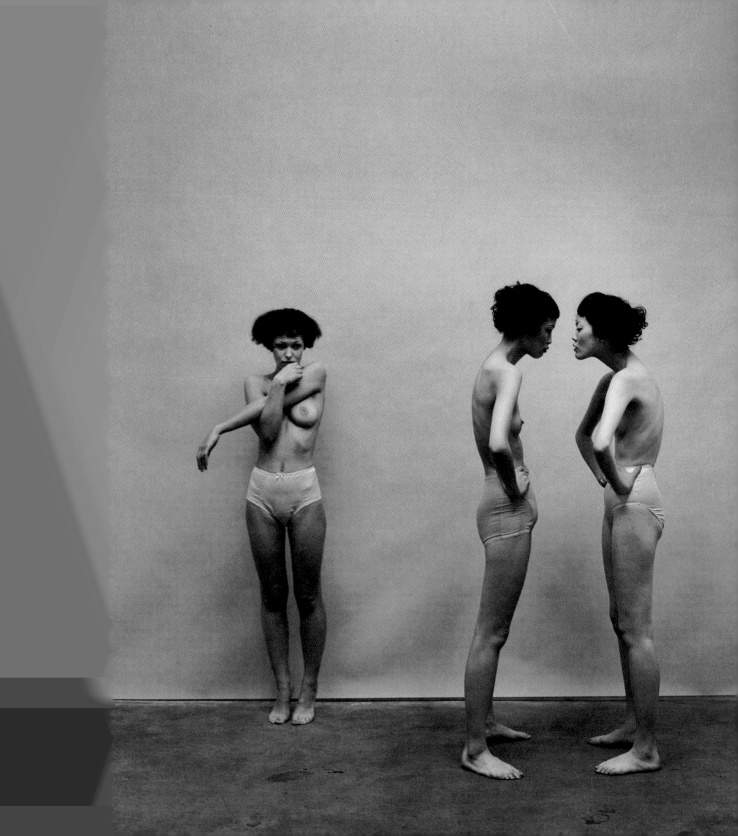

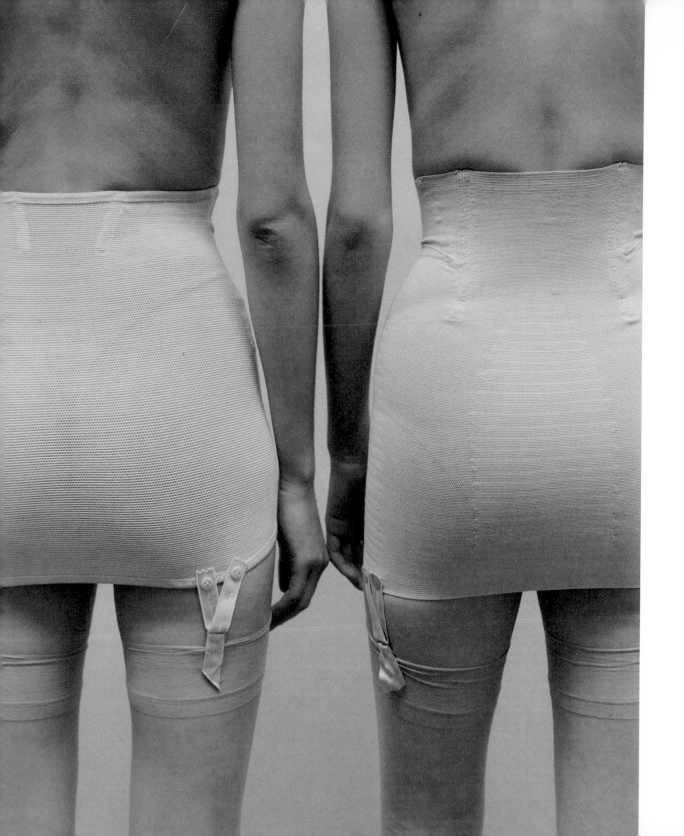

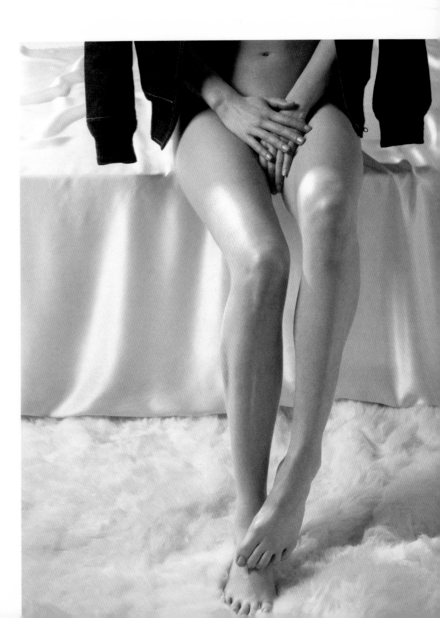

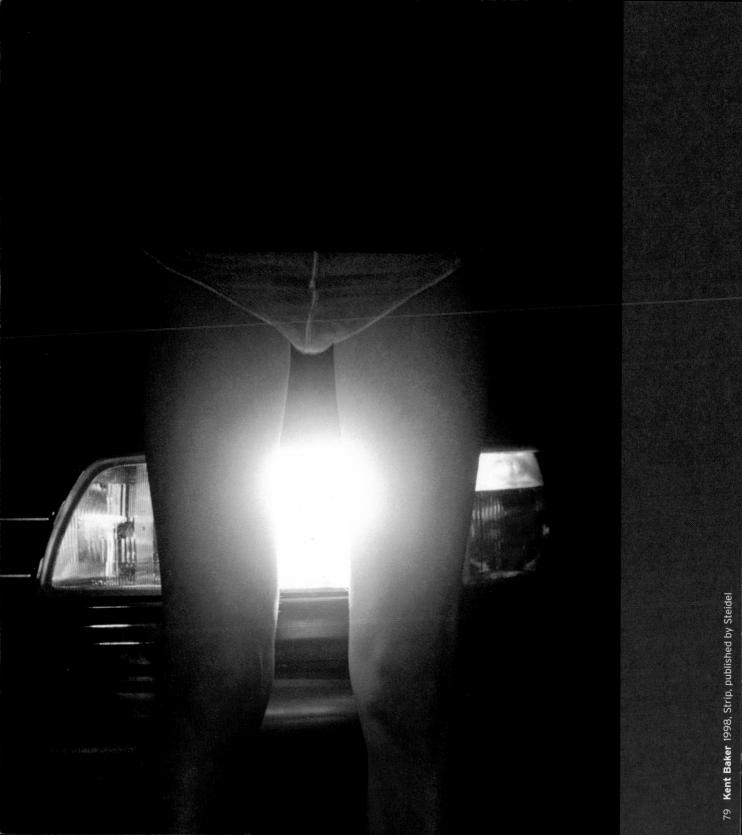

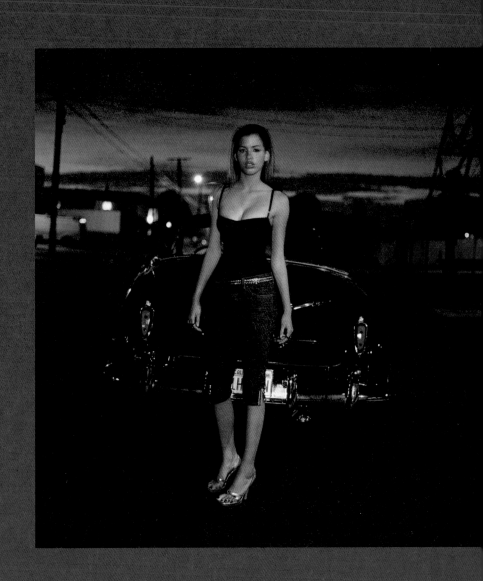

Taryn Simon 1999

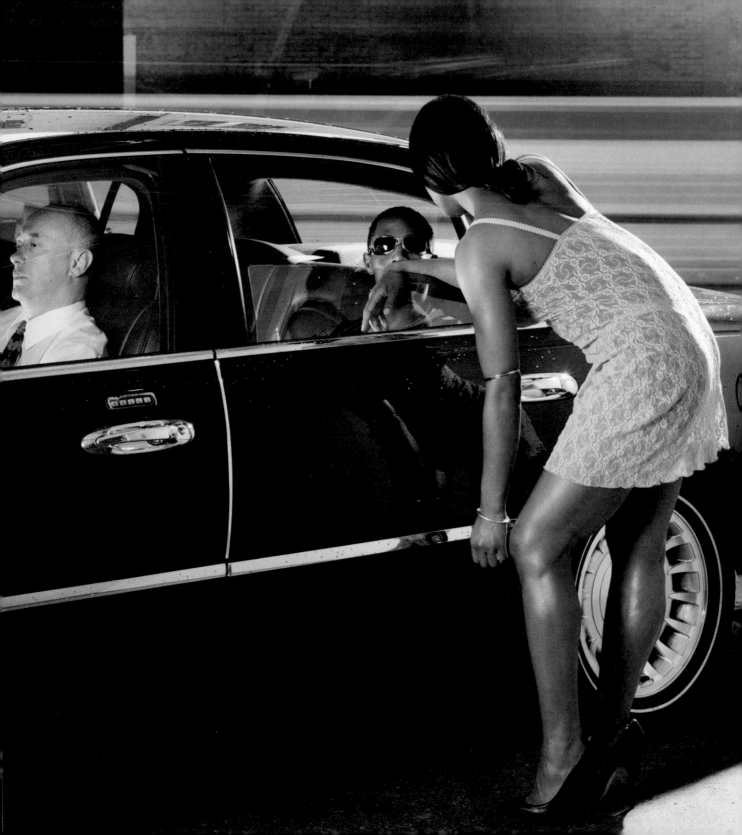

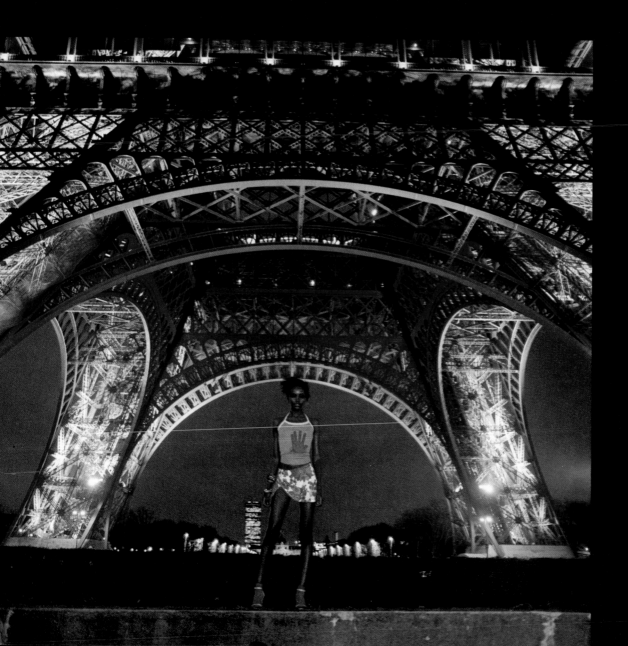

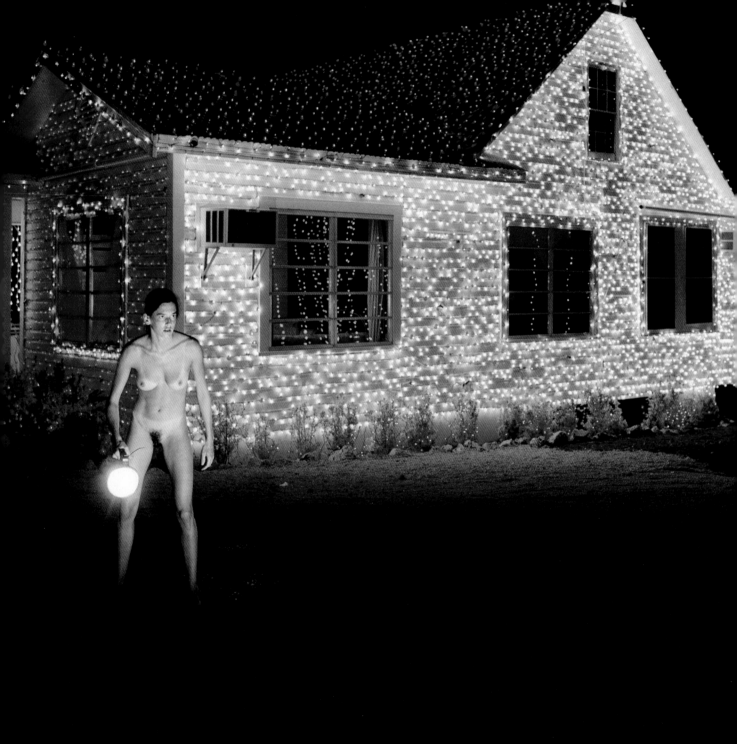

83 **Taryn Simon** 1999

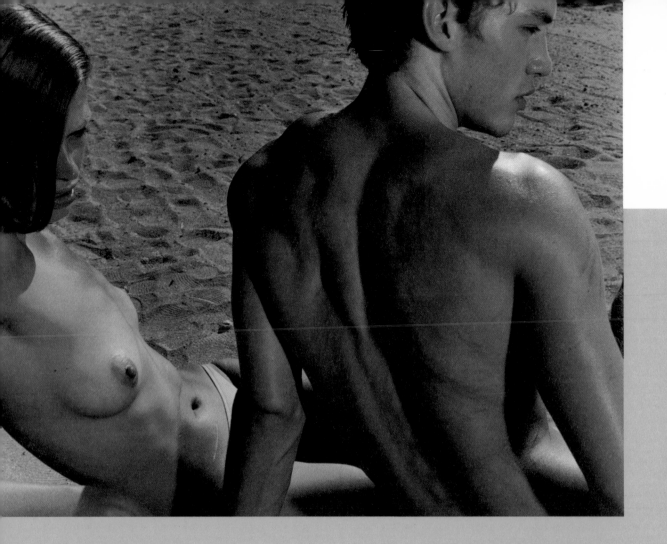

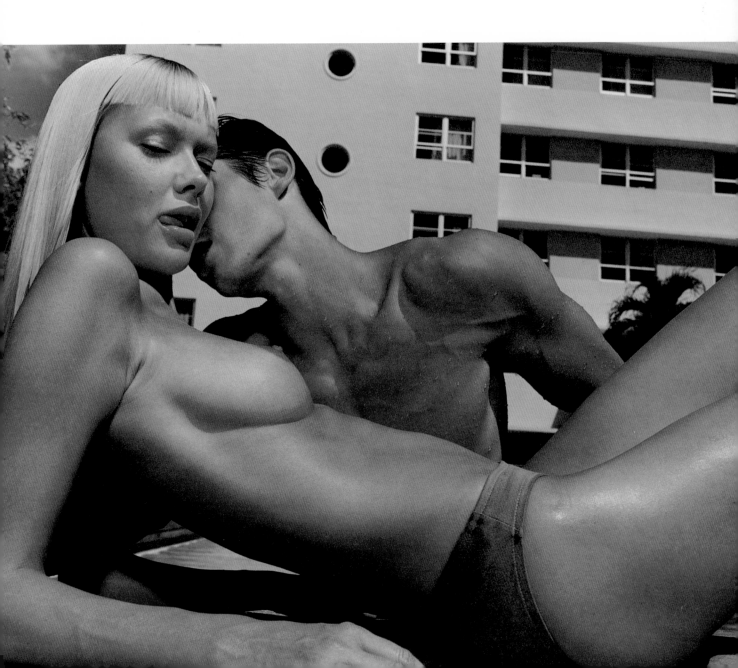

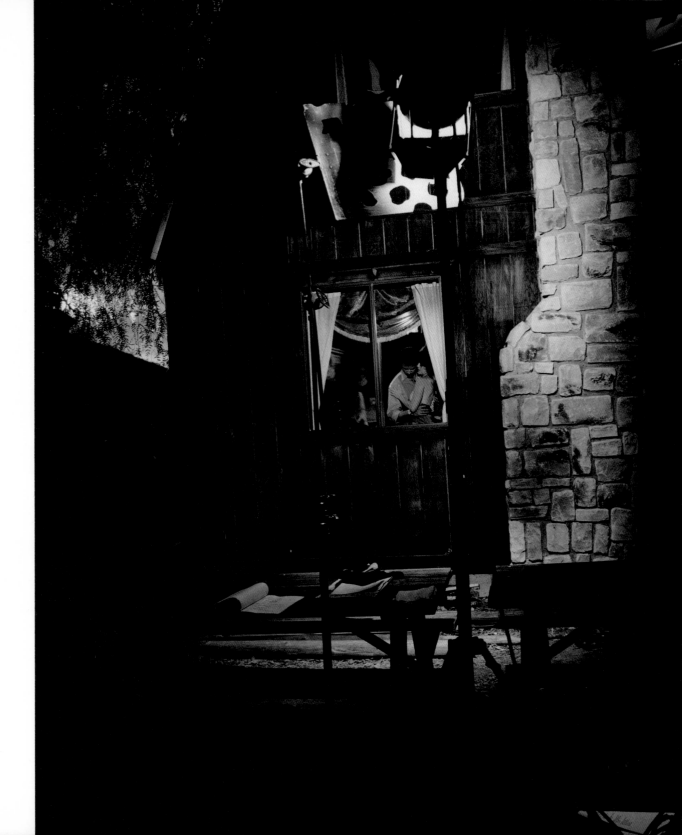

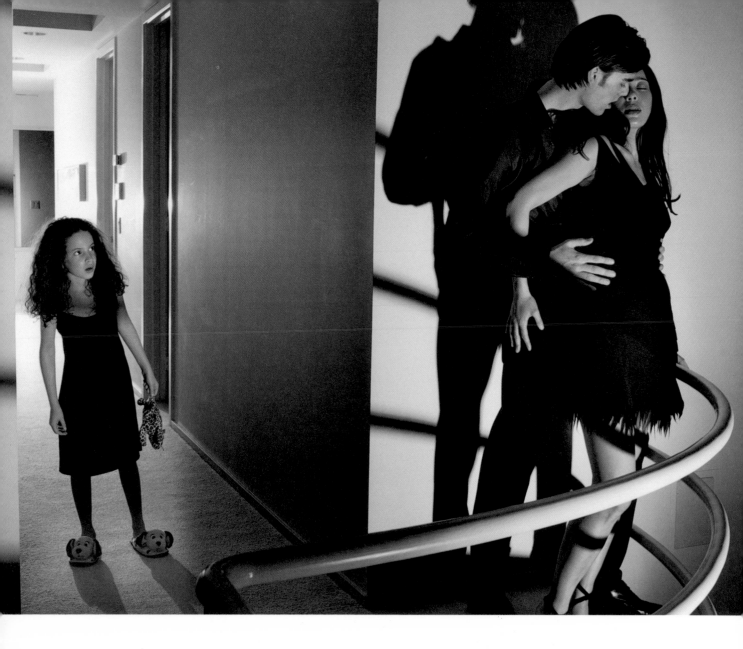

Gillian Laub 1999

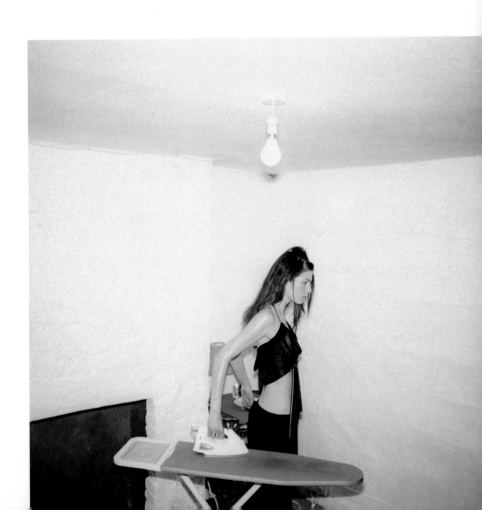

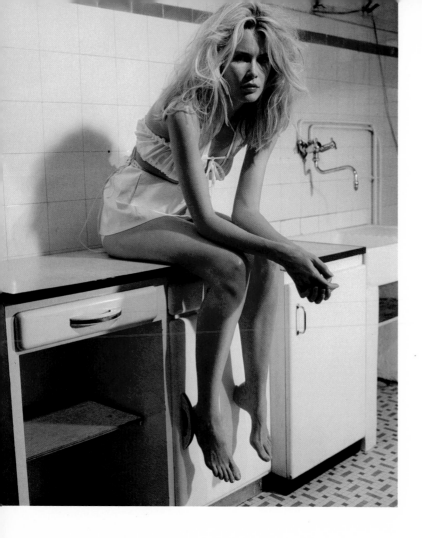

90 **Bettina Rheims** 1999, Detour

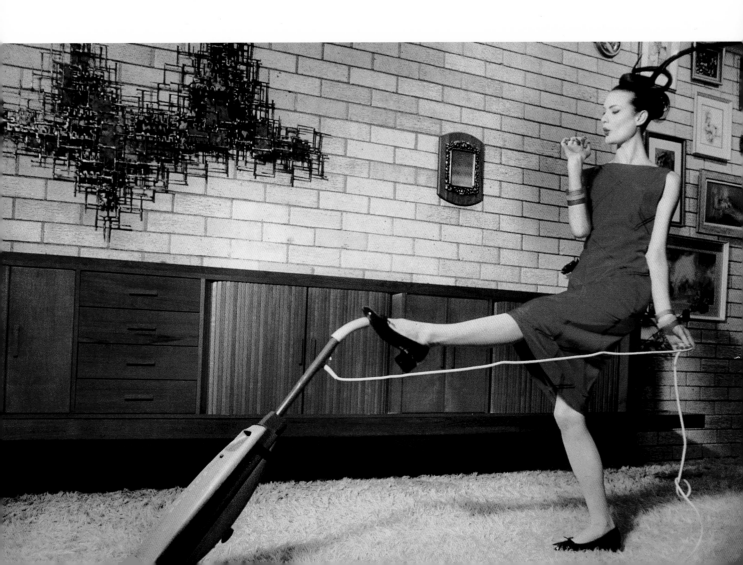

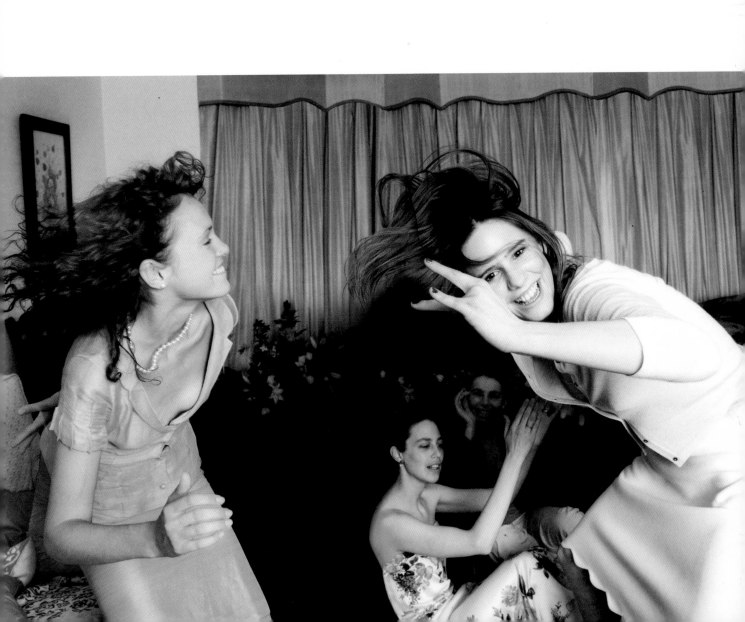

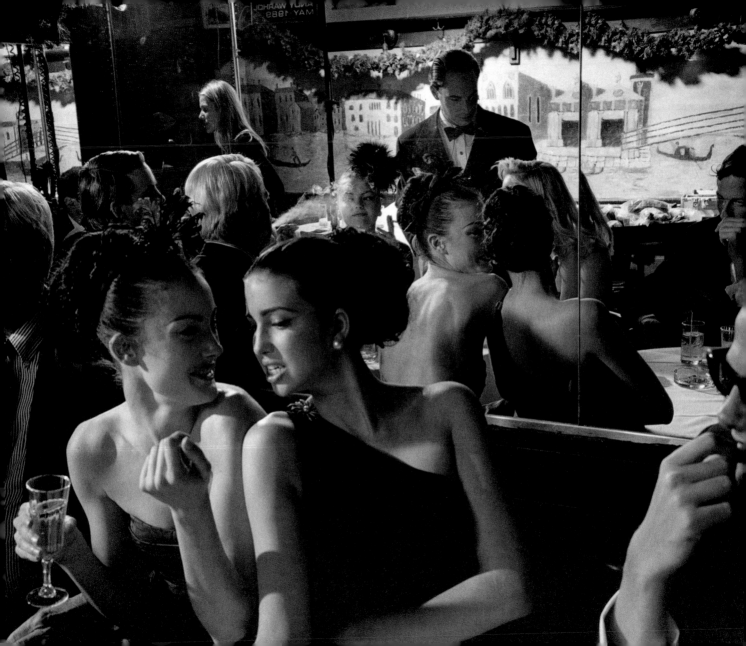

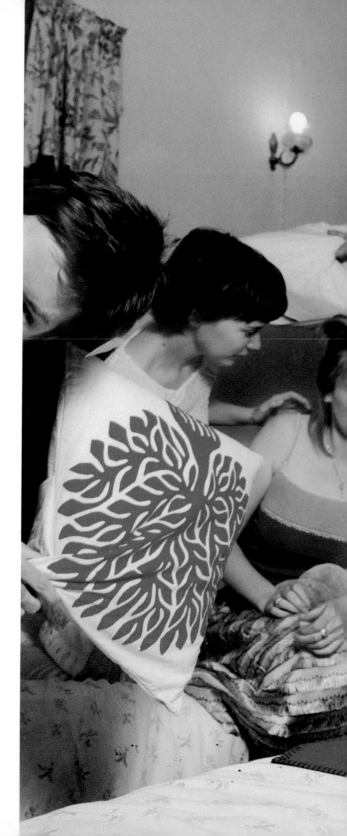

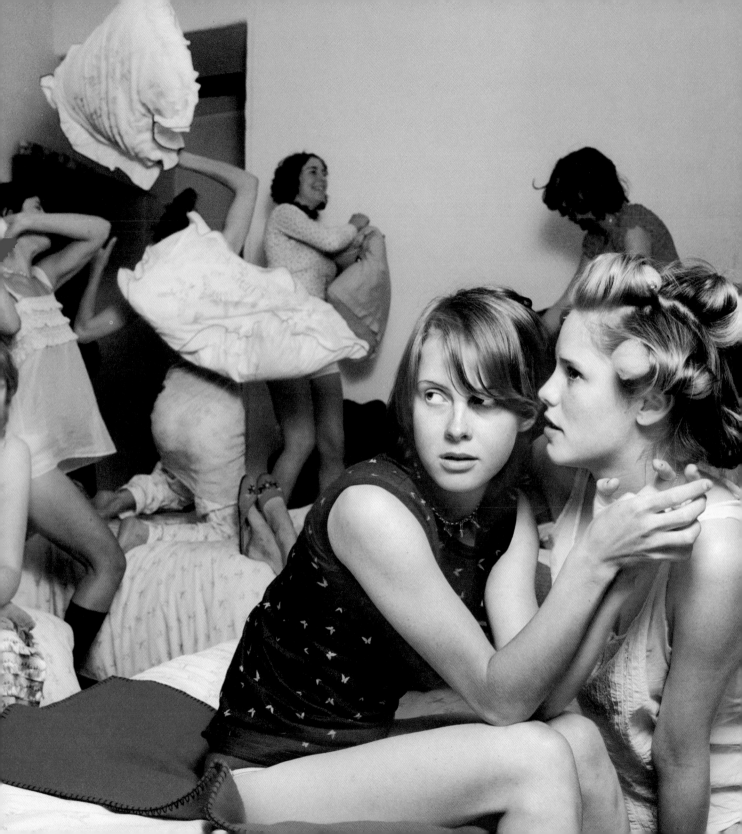

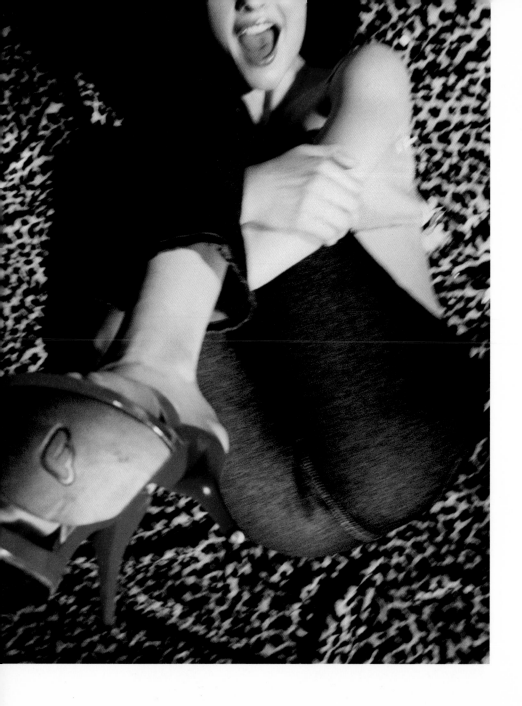

95 **Jennifer Robbins** 1999, Detour

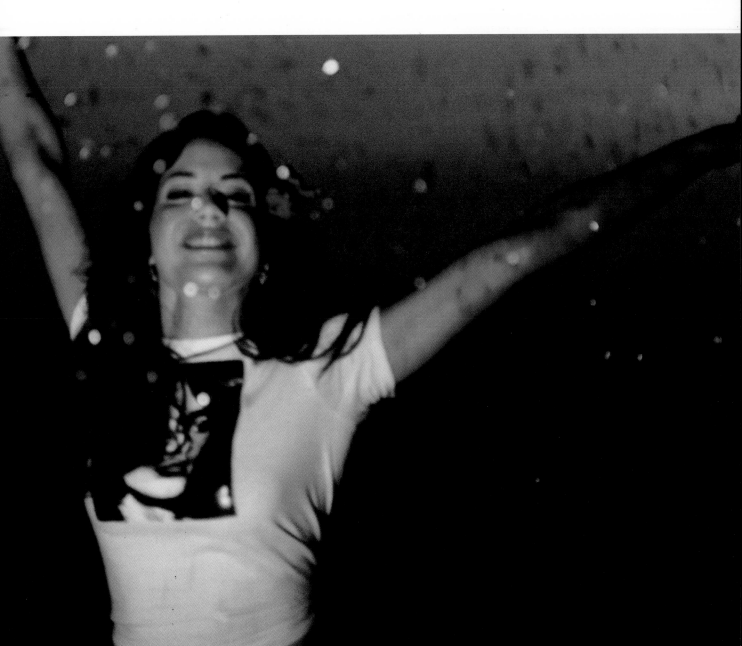

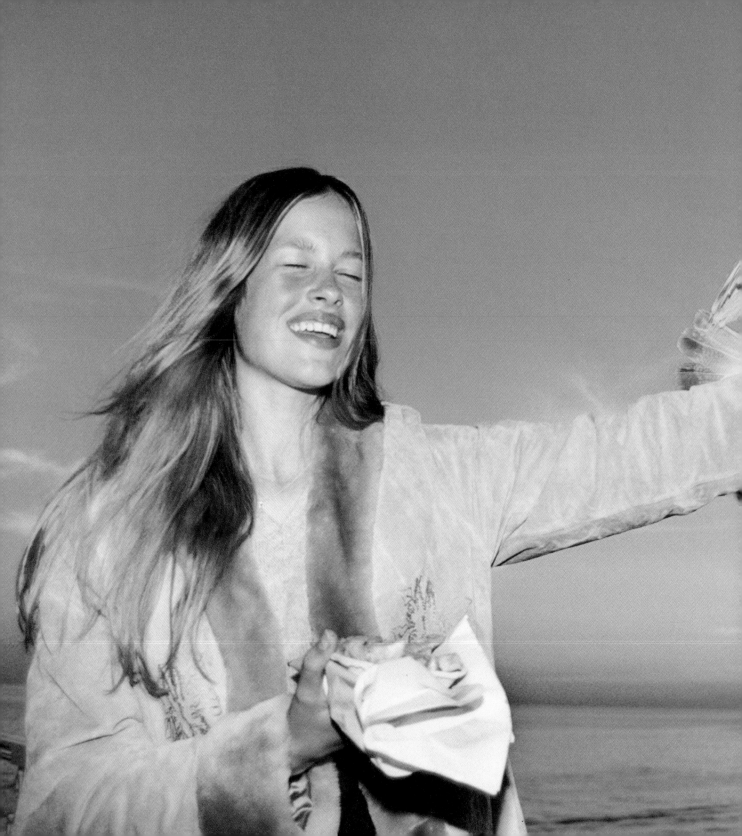

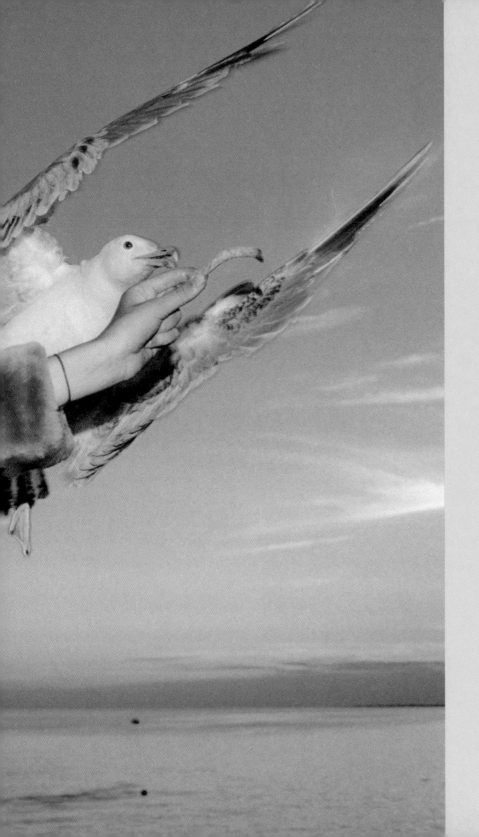

97 **Elaine Constantine** 1997, The Face

Photographer Biographies

Born in England in 1996, **John Akehurst** lived in New York after graduating from university with a degree in photography. In New York, while an assistant to Albert Watson and Steven Meisel, he received commissions from *Arena Homme Plus* and *The Face* magazines. His fashion stories have appeared in *Spin, Dazed & Confused, Dutch, Visionaire, The Face,* and *Frank*. In 1998 he was nominated as Young Photographer of the Year from the International Festival de la Mode.

Alex + Laila are an inseparable photography team. New Jersey-native Alex, and London-native Laila met at the School of Visual Arts (SVA) in New York. Alex studied photography at SVA and Laila studied graphic design at Central St. Martins in London. They met in 1997 while Laila was taking a photography course at SVA and have been collaborators ever since. Alex + Laila's images have appeared in *Paper, Surface, Spin, Detour, Elle, Pil,* and *i-D* magazines.

Londoner **Kent Baker** currently contributes to magazines such as *Raygun, Dutch, Arena, i-D, Frank, Spin, Interview,* and *Vibe*. His portrait work features Antonio Berradi, the Charlatans, Roni Size, and Earl Brutus. Mr. Baker has recently been commissioned to produce a book, *66–99,* a photographic and oral history of Route 66.

Lillian Bassman was born in New York in 1917. Among the masters of fashion photography, she reigns as the doyenne of the postwar period. She began her career in the 1940s as an apprentice to the legendary Alexey Brodovitch at *Harper's Bazaar*. In 1945 she was named art director of *Junior Bazaar* magazine, where she hired young photographers, among them Richard Avedon, Robert Frank, and her husband, Paul Himmel. Throughout the 1950s and 60s, Lillian Bassman worked at fashion's cutting edge, both as an art director and photographer. In addition to her editorial work, she shot campaigns for Chanel and Balenciaga. In the 1970s she put aside commercial photography for personal photography projects. Now in her 80s, she is enjoying a new-found celebrity and working again in both editorial and advertising fashion photography. In the past several

years she has had exhibitions worldwide and her long-awaited monograph was published in 1996. She lives in New York with her husband, Paul Himmel.

Julian Broad was born in England in 1964. He began his photography career assisting Lord Snowdon and went out on his own at the age of twenty-three. In 1989 he had an exhibition at Hamilton's Gallery in London. Among his portraits are those of Sir Anthony Hopkins, Giorgio Armani, Damien Hirst, Dolce & Gabanna, Hugh Grant, Kurt Cobain, Margaret Thatcher, and Nelson Mandela. His advertising clients include BMW, Harvey Nichols, Microsoft, and Paul Smith. His editorial work can be seen in *Elle, Frank, George, German Amica, Vanity Fair,* and *Vogue* magazines.

London-based **Donald Christie**, who received a fine arts degree from the Polytechnic of Newcastle upon Tyne, has applied himself to fusing his knowledge of fine art techniques with editorial fashion work. His photographs have appeared in such publications as *Arena, i-D, The Face, Details, Raygun, Dazed & Confused,* and *Spin.* He has also distinguished himself as a portraitist of various musicians and their bands. Christie's advertising clients include Levi's, Nike, Diesel, and Converse. More recently he has completed two short fashion-based films for the Florence Biennale in 1998. Donald Christie has also taught photography to the elderly and mentally handicapped.

Matthias Clamer received his BA from the University of Lancaster, England. He has won numerous awards and merits, including the John Kobal Foundation Award from the National Portrait Gallery in 1995. His work can be seen in magazines such as *Details, Elle, Spin, Detour, Raygun, Paper,* and *Sleazenation.* His advertising work includes clients such as Levi Strauss, Canon, Rebecca Danenberg, and Mountain Dew. Clamer currently lives and works in New York City.

Elaine Constantine was born in Manchester, England, in 1965. She first became interested in photography when as a teenager she was part of the northern soul scooter scene in Manchester. She moved to London in 1992 to become a photographer's assistant. In 1993 she began working independently and has since been commissioned by magazines such as *The Face, Arena Homme Plus, i-D,* Italian *Vogue,* American *Vogue, W* magazine, and *Spin.* Her advertising clients include Katharine Hamnett, Anna Mollinari, Alberto Biani, and Jigsaw. Ms. Constantine's work has been featured in a number of exhibitions and books, including the British Council's exhibition of British fashion photography titled "Look At Me." Her work recently won a prize from the John Kobal Foundation, and her first solo exhibition was held last year at Marion de Beaupré's Galerie 213 in Paris. Constantine's contribution to photography has recently been nominated for the City Bank photography prize 2000.

Wendelien Daan was born in the Netherlands in 1965. She studied fashion design at the Academy of Arts in Arnhem. In 1989 she moved to Amsterdam, and a year later she received a scholarship from The Netherlands Foundation for fine arts, design & architecture. She does editorial work for *Squeeze, Dutch, Elle, Jalousse, Frank,* and *Visionaire.*

Dah Len was born in Taipei, Taiwan, and attended A-level public school in England. He came to America to study architecture at the University of California, Berkeley. After graduation, he moved to New York, took up photography, and has since become one of fashion's top photographers. Dah Len's work can be seen in such magazines as *Allure, Detour, Esquire, Flaunt, Mademoiselle, Vibe, W,* and *Surface.* His advertising campaigns include Guess?, Charles David, Patrick Cox, Levi's, Joop, Revlon, and L'Oréal. He is currently working on recording his own music between photography assignments.

Larry Fink has more than sixty prints in the permanent collection of the Museum of Modern Art, New York. He has received two Guggenheim fellowships and two NEA endowments, and presently has a career retrospective touring museums in Europe. Mr. Fink's published books include *Runways* (a book on the fashion industry), *Social Graces,* and *Boxing.* His editorial work has appeared in the *New Yorker, W, GQ, Rolling Stone, Details,* and the *New York Times Sunday Magazine.* In May 1997, he won the Society of Publication Designers Gold Medal with Dennis Freedman at *W* magazine for his story looking at the world behind the scenes at fashion shows. Mr. Fink is currently a tenured professor of photography at Bard College.

Dutch photographer **Carmen Freudenthal** was born in 1965. She studied at the Vrije Academie in The Hague and from 1983–88 studied at Gerrit Rietveld Academie in Amsterdam. In 1989 she won the Kodak Award in the Netherlands and in 1998 the European regional Design Annual Certificate of design excellence. Her work has appeared in *i-D, Esquire, Elle,* and *Vogue* magazines.

A native of Chicago, **Alex Freund** studied photography at the Parsons School of Design, from which he graduated in 1998. His work appears in *Wired, Detour, Hint,* and *Trace* magazines.

Jamil GS was born and raised in Copenhagen, Denmark. He began experimenting with graffiti art on trains at the age of twelve, and at eighteen moved to New York to study Computer Graphics and Product Design at the Parsons School of Design. His work can be seen in *Arena, Vibe, Interview, The Face, Dazed & Confused, Raygun, Spin, George,* and *i-D* magazines. His work has been exhibited internationally since 1996.

Marie-Jose Jongerius was born in Bilt, The Netherlands, in 1970. From 1991–92 she studied photography at the Instituto Superiore della Fotografia in Rome, and then spent the next four years of study at the Royal Academy of Visual Arts, The Hague. Her work has been shown throughout Europe and has been published in such magazines as *Elle, Blvd.,* and *Chiq.*

Marcelo Krasilcic is a Brazilian photographer who has lived in New York City since 1990. He graduated from New York University with a BFA in photography and since then has developed a multifaceted career, with projects that involve art, fashion, and architectural photography. His work has been shown in galleries and *The Face.*

Born in 1975, **Gillian Laub** was raised in New York City. She graduated with a degree in literature and psychology from the University of Wisconsin at Madison. She studied photography at the International Center for Photography in Manhattan, and cites filmmakers Godard, Cassavetes, Bergman, and Truffaut as influences on her work.

Peter Lindbergh dropped out of school at the age of fifteen to work as a window dresser. Four years later, he moved from his native West Germany to Lucerne, Switzerland. Within a year he was living in Berlin and working at odd jobs. He was twenty-seven when he picked up a camera for the first time. Shortly afterward, he became an assistant to photographer Hans Lux. Peter Lindbergh's photographs have since appeared in every major fashion magazine, including American, British, French, and Italian *Vogue, Allure,* and *Harper's Bazaar,* to name a few. During the last four years he has photographed ad campaigns for Giorgio Armani, Prada, Calvin Klein, Jil Sander, and others. In addition to still photography, Peter Lindbergh also directs television commercials, and in 1992 he directed his first documentary film, "Models – the Film." Peter Lindbergh currently divides his time between Europe and the United States and travels extensively on loca-

tion. His constant exposure to the cultures of often widely disparate continents enables him to view contemporary life in a broad and encompassing way.

Dana Lixenberg was born and raised in Amsterdam, the Netherlands. She studied photography at the Gerrit Rietveld Academie in Amsterdam as well as the LCP in London. She is a frequent contributor to magazines such as *Arena, Icon, i-D, Dazed & Confused, Big,* and *Rolling Stone.*

A native of Italy, **Tiziano Magni**'s work has been published for nearly 20 years, and has appeared in magazines such as American, Italian, and French *Vogue, Harper's Bazaar, Elle, Marie Claire,* and *Mirabella.* He has done advertising campaigns for Calvin Klein, Missoni, and Malo. Magni lives in New York.

Mark Mattock was born in England in 1963. He currently lives in London where he does portrait and fashion photography. Among his advertising clients are Nike, Adidas, Pepe, Levi's, Docker's, and Carlsberg beer. His editorial work can be seen in *i-D, Arena, The Face, Visionaire, George,* British, American and French *Vogue.*

After spending the last four years working out of Paris and Milan, **Donald McPherson** has made the U.S. his home once again. He spends most of his time traveling between New York and Los Angeles. McPherson has worked extensively with many Japanese designers, and has photographed ad campaigns for Paul Smith, Byblos, and Levis. His editorial work has appeared in *Interview, Arena, D* magazine, *Mondo Uomo,* and *Spin.*

Dana Menussi was born in Tel Aviv, Israel, where she has become a renowned photographer for various Israeli publications. Having moved to New York a few years ago, her work has since been published in *Raygun, Jane, Wired,* and Spanish *Harper's Bazaar.* She

recently shot her first major ad campaign for Equipment and is currently working on a fashion story for *Arena Homme Plus.*

Jeff Minton was born in San Francisco in 1973. He studied marine biology at the University of California at Santa Barbara before attending Art Center College of Design in Pasadena, where he majored in photography. His work is published in *Detour, Spin, Wired, Icon,* and *Urb.* Minton lives in Pasadena.

Sarah Moon has been working in fashion and advertising photography since 1968. Her work has appeared in *Elle, Harper's Bazaar, Marie Claire,* and *Vogue,* to name a few. She has had one-person photography shows around the world since 1983 and has published four books. She has directed numerous television commercials, including ads for Barney's, L'Oréal, Revlon, TWA, Singapore Airlines, and DuPont. She has been the recipient of numerous distinctions, including the Gold Award for Applied Photography, the International Center for Photography, 1985, New York, the Grand Prix National de la Photographie, Paris, 1995, and the BFF in Dresden, 1996. Ms. Moon currently resides in Paris.

Dutch photographer **Johanna Martien Mulder** was born in 1971. She has worked in Europe as a video artist and photographer. Fashion editorials include *Dutch, Purple, Squeeze,* and *Vogue.* Advertising clients include Pepe Jeans, Le Souk, and Rothmans. Mulder has done video projects for Levi Strauss and VPRO TV.

Jeremy Murch is a London-based photographer whose work can be seen regularly in *The Face, i-D, Arena, Interview, Vogue,* and *Spin.* He has had numerous exhibitions, and is currently working with award-winning BBC documentary filmmaker Lucy Blaksted on the project "Naked." "Naked" will explore the attitudes of

different generations' feelings about their bodies and sexuality, and will be developed into a book in association with the forthcoming documentary series.

Rankin co-founded London-based style magazine *Dazed & Confused* in 1991. The magazine quickly grew and is now internationally recognized as a barometer for what is current in fashion and music trends. Rankin has photographed nearly every cover story for *Dazed & Confused,* and is responsible for much of the magazine's creative reputation. He also works regularly for *GQ* magazine, *Spin,* and *Big.* Most recently, he has been commissioned to shoot advertising campaigns for Diesel, Schweppes, Givenchy, and Paul Costelloe.

Bettina Rheims was born in Paris in 1952. She began photographing striptease artists and acrobats in the late 1970s. In 1981, she had her first exhibition at the Pompidou Center in Paris. She is the author of two books, *Bettina Rheims* and *Female Trouble.*

Christophe Rihet was born in Enghein, France. He credits Rembrandt, van Gogh, and the Surrealists as influencing his love of rich, magical, atmospheric scenes. He studied photography at the Louis Lumiere School of Photography. His work can be seen regularly in *Frank, Allure, Jane, W,* and *Arena.*

Jennifer Robbins was born in 1974 and was raised in New York City. She cites Ellen Von Unwerth and Terry Richardson as inspiration for her work. Robbins's photographs have been featured in *Glamour* and she is a regular contributor to *Detour* magazine.

Paolo Roversi was born in 1947 in Ravenna, Italy. He became a photojournalist at the age of 20, but became interested in fashion photography in 1973. Since that time, his work has appeared in *Harper's Bazaar,* Italian and British *Vogue, L'Uomo Vogue, Interview, Arena,* *i-D, W,* and *Marie Claire.* His advertising clients include Giorgio Armani, Comme des Garçons, Christian Dior, Givenchy, Yves Saint-Laurent, and Yohji Yamamoto. Roversi has directed television commercials for Dim, Evian, and Kenzo and has had numerous one-man photography shows. Paolo Roversi has lived and worked in Paris since 1973.

Stefan Ruiz was born in San Francisco and raised on the West Coast. He studied fine art at the University of California at Santa Cruz. Following an assignment in West Africa, he chose to specialize in photography. On returning to California, he taught art for seven years to inmates at San Quentin State Prison while also pursuing his freelance career. He recently stopped teaching and has moved to New York. His work can be seen in the *New York Times Sunday Magazine, Arena, Details, Dazed & Confused,* and *i-D* magazines.

Stephane Sednaoui was born in Paris in 1963. He began photographing in 1986, and since 1991 has been based in New York. That same year, he began directing music videos. His photography has appeared in *Detour, Visionaire, Flaunt, Interview, The Face,* and *i-D* magazines, among many others. He has directed music videos for Sheryl Crow, the Red Hot Chili Peppers, Tina Turner, Madonna, and U2. His television commercials include Nike, Coca-Cola, and Levi's.

Catherine Servel was born in 1973 in Brittany, France, and as a young girl moved to the south of France. She studied graphic design in Paris at the Penninnghin School of Design, graduating in 1996. She then moved to New York City and briefly studied photography at SVA (School of Visual Arts). Her work has been published in *Paper* and *Surface* magazines.

Stewart Shining was born in 1964 in South Dakota. He went to Parson's School of Design and received his

BFA in 1982. His editorial work regularly appears in *Marie Claire, Rolling Stone, Wallpaper, W, Vanity Fair,* and *Us* magazines. His advertising clients include Polo-Ralph Lauren, Perry Ellis, L'Oréal, and Victoria's Secret.

Photographer **Taryn Simon**, twenty-four years old, works out of New York City. She recently graduated from Brown University and studied photography at the Rhode Island School of Design and Speos Photographic Institute, Paris. Ms. Simon works exclusively in large format both for galleries and publications such as *Visionaire, Big, Flaunt,* and French *Vogue.*

Umberto Stefanelli was born in Rome in 1967. He has created images for Piercouture, a designer who creates clothes out of natural hair. More recently, Stefanelli has collaborated with the Levi Strauss Company on their advertising campaign that was exhibited at the Levi's Gallery in New York City.

Cleo Sullivan has been living between New York and Paris for the past six years. She studied art at the Pennsylvania Academy of Fine Arts in Philadelphia. Her photographs have appeared in French *Vogue, Allegra,* Italian *Glamour, Allure,* the *New York Times Sunday Magazine,* and *Vogue.*

Larry Sultan, who has received various awards, including fellowships and grants from the Guggenheim Foundation and the National Endowment for the Arts, is world-renowned for his work. He has had exhibitions at the Museum of Modern Art, New York, the Corcoran Gallery of Art, the San Francisco Museum of Modern Art, and the Bibliothéque Nationale, Paris. He is currently working on a book of photographs taken on the sets of pornographic films. Larry Sultan is the chair of the photography department of California College of Arts and Crafts, San Francisco.

Born in Tacoma, Washington, **Michael Thompson** attended the Brooks Institute of Photography, Los Angeles, for three years. He assisted various photographers for six years and then moved to New York City to set out on his own. Thompson shoots regularly for *W,* French *Vogue,* German *marie claire, Frank,* and *Jane.* His advertising clients include Ralph Lauren eyewear and accessories, Chanel, Estée Lauder, Issey Miyake, Hugo Boss, Revlon, Valentino, and Escada.

Anna Tiedink was born in 1970 and graduated from the Royal Academy of Fine and Applied Arts, The Hague, in 1995. In 1997 she received the Photographers Association of the Netherlands Silver Award for Fashion.

Marcus Tomilson was born and raised in England. For much of the early 1990s he did work for *The Face,* along with advertising campaigns for Christian Lacroix, Koji Tatsumo, and various record companies. He then went on to photograph for *Visionaire,* first with hat designer Phillip Treacy and then with the designer Hussein Chalayan. This collaboration with Hussein has led to a number of international gallery exhibitions, most recently at the Atlantis Gallery in London. More recently his work has appeared in *i-D* and *Composit* magazines. Tomilson lives in London.

Tom van Heel was born in the Netherlands in 1960. He was trained as a language teacher and also has a degree in audiovisual communications. In the late 1980s he taught photography to runaway kids. At the age of thirty-one he began his professional photography career. His editorial work has been published in *Marie Claire, Harper's Bazaar, Votre Beauté, 20 Ans,* and *Arena* magazines.

Edel Mary Verzijl was born in the Netherlands in 1960. She graduated with a degree in painting and drawing and followed that with a doctoral degree in philosophy and arts. She studied textile design and fashion and

had her own clothing business for four years. She then began working as a stylist and returned to her original love of photography. She has exhibited widely throughout Europe and been published in *Squeeze, Avant-garde, Esquire,* and *i-D* magazines.

After graduating from high school, **Ellen von Unwerth** joined the circus. From there she became a model and ten years later, became a photographer. Her work has since appeared in American, Italian, and British *Vogue, Vanity Fair, Interview, The Face, Arena, L'Uomo,* and *i-D.* Her major advertising campaigns include Guess Jeans, Diesel, Chanel, Katharine Hamnet, Miu Miu, Bluemarine, and Adidas. She has been awarded first prize at the International Festival of Fashion Photography, has had a one-woman show at Hamiltons Gallery in London, and has directed music videos for Duran Duran, N'Dea Davenport, Salt n' Pepa, and television commercials for Clinique and Parco in Japan. She has published three books, *Snaps, Wicked,* and *Couples* in 1999. She lives in New York City.

Jelle Wagenaar was born in Leeuwarden, Holland, in 1965. After pursuing a variety of interests, Wagenaar began working as a portrait photographer in Amsterdam. He moved to Germany, where he began working for fashion magazines, and in May 1997 he moved to New York. His work has since been published in *Spin, The Face,* and *Detour* magazines.

A native of England, **Tim Walker** graduated from Exeter Art College in July of 1994. He continued his training as a photographic assistant and soon established himself as a photographer in his own right by taking on small documentary, fashion, and portrait commissions from the *Independent.* He has gone on to work for British and Italian *Vogue, Arena,* German *Marie Claire, Interview,* and *Allure.* His advertising clients include Barney's, Levi's UK, and Banana Republic.

Christian Witkin was born in Manchester, England. He lived in Amsterdam until 1984, when, at the age of seventeen, he moved to America, where he continued his education at Syracuse University in Fine Art and Photography. His work can be seen in British, American, and German *Vogue, Harper's Bazaar, New York Times Sunday Magazine, Interview, Vanity Fair, Spin, Detour, The Face,* and *i-D* magazines. He has completed advertising campaigns for Nike, I.B.M., Microsoft, Calvin Klein, and DKNY. He has received numerous awards from *American Photography* and *Communication Arts* magazines, and most recently was the recipient of the Society of Publication Designers Gold Award in Photography. His personal work has been exhibited in New York, Amsterdam, and Paris, and he has recently published his first book, *India: Street Mythology.*

List of Plates

1
Photographer: John Akehurst
Model: Gisele
Publication: The Face
Date: 1999

2
Photographer: Donald Christie
Model: Nancy Hagen
Stylist: Anne Christensen
Publication: Frank
Date: 1998

3
Photographer: Donald Christie
Model: Lynda Byrne
Hair & Makeup: Karl Berndsen
 at Marina Jones
Stylist: Jo Baker at John
 Parkinson
Publication: Italian Amica
Date: 1999

4
Photographer: Alex + Laila
Models: Nikki, Vanessa & Shauna
Hair: Rick Gradone for Oribé
Makeup: Yuki Wada
Stylist: Colleen Brennan
Publication: Detour
Date: 1999
Designer: Blumarine, Barbara
 Bui, Dolce & Gabbana, BCBG

5
Photographer: Alex + Laila
Models: Nikki & Vanessa
Hair: Rick Gradone for Oribé
Makeup: Yuki Wada
Stylist: Colleen Brennan
Publication: Detour
 (unpublished)
Date: 1999

6
Photographer: Julian Broad
Publication: Australian Vogue
Date: 1998

7
Photographer: Marcelo Krasilcic
Model: Craig Destefano
Hair & Makeup: Mira
Publication: Spin
Date: 1998

8
Photographer: Donald
 McPherson
Model: Melanie Thierry
Hair: Karim Mitha
Makeup: Irena Ruben
Stylist: Sara Ghazi-Tabatabai
Publication: Chiq
Date: 1999

9
Photographer: Marcus Tomilson
Model: Clare Wilson
Stylist: Eugenie Hanmer
Publication: Frank
Date: 1998

10
Photographer: Stefan Ruiz
Client: Cat/Caterpillar Campaign
Date: 1998

11
Photographer: Carmen
 Freudenthal
Models: Olga & Jill
Hair & Makeup: TacoatAda
Stylist: Elle Verhagen
Publication: Blvd.
Date: 1999

12
Photographer: Kent Baker
Client: Steidel Publishing
Model: Mica
Hair: Jonny Drill
Makeup: Sharon Dowsett
Stylist: Felix
Publication: Strip
Date: 1999

13
Photographer: Carmen
 Freudenthal
Model: Jill
Hair & Makeup: TacoatAda
Stylist: Elle Verhagen
Publication: Blvd.
Date: 1999

14
Photographer: Rankin
Client: Diesel Style Lab
Date: 1999

15
Photographer: Alex + Laila
Model: Nikki
Hair: Rick Gradone at Oribé
Makeup: Yuki Wada
Stylist: Colleen Brennan
Publication: Detour
Date: 1999
Designer: DKNY

16
Photographer: Jeff Minton
Stylist: Scott Free
Publication: Detour
Date: 1999
Designer: Spitfire & Hoodie

17
Photographer: Stewart Shining
Client: Polo
Model: Tanga
Hair: Didier Malige
Makeup: Christy Coleman
Date: 1999

18
Photographer: Stewart Shining
Client: Polo
Model: Tanga
Hair: Didier Malige
Makeup: Christy Coleman
Date: 1999

19
Photographer: Dana Lixenberg
Model: Annette Torres
Stylist: John Moore
Publication: Blaze
Date: 1999

20
Photographer: Michael
 Thompson
Model: Carolyn Murphy
Publication: W
Date: 1999
Designer: Michael Kors for Celine

21
Photographer: Ellen von Unwerth
Model: Shalom Harlow
Publication: Italian Vogue
Date: 1999
Designer: Blumarine, Philip
 Treacy (hat)

22
Photographer: Tim Walker
Model: Heather Robinson
Stylist: Sissy Vian
Publication: Italian Vogue
Date: 1998

23
Photographer: Tim Walker
Publication: Italian Vogue
Date: 1999

24
Photographer: Jennifer Robbins
Model: Johanna
Hair: Matthew Williams
Makeup: Edward Cruz
Stylist: Colleen Brennan
Publication: Detour
Date: 1999
Designer: Norma Kamali, Guess?

25
Photographer: Ellen von Unwerth
Model: Shalom Harlow
Publication: Italian Vogue
Date: 1999
Designer: Philip Treacy (hat)

26
Photographer: Peter Lindbergh
Models: Zoe & Seijo
Publication: Italian Vogue
Date: 1998
Designer: Prada

27 & 28
Photographer: Edel Verzijl
Model: Winnie
Hair & Makeup: Sil at House
 of Orange
Stylist: Caroline Fuchs
Publication: 2wice
Date: 1999

29
Photographer: Cleo Sullivan
Model: Maryanne Schroder
Hair: Frankie Foye

Makeup: Susan Howser
Publication: Italian Amica
Date: 1999

30
Photographer: Anna Tiedink
Model: Radana
Hair & Makeup: Ingrid Boekel
 at House of Orange
Stylist: Alex Steen
Date: 1998

31
Photographer: Tiziano Magni
Model: Michelle Hicks
Publication: Mirabella
Date: 1999

32
Photographer: Matthias Clamer
Hair: Stacey Ross
Makeup: Nao
Stylist: Christine Baker
Publication: Paper
Date: 1999

33
Photographer: Lillian Bassman
Model: Shalom Harlow
Hair & Makeup: Robertino
Stylist: Franz Ankone
Publication: Detour
Date: 1999
Designer: Mila Schon

34
Photographer: Lillian Bassman
Model: Shalom Harlow
Hair & Makeup: Robertino
Stylist: Franz Ankone
Publication: Detour
Date: 1999
Designer: Blumarine

35
Photographer: Donald McPherson
Model: Hanki
Hair: Karim Mitha
Makeup: Irena Ruben
Stylist: Nathalie Croquet
Publication: Chiq
Date: 1999

36
Photographer: Rankin
Client: Diesel Style Lab
Model: Jamiee
Date: 1998

37
Photographer: Rankin
Client: Diesel Style Lab
Stylist: Kees Kreuter & Karrin
 Rode at Diesel
Publication: Diesel catalogue,
 Dazed & Confused
Date: 1998

38
Photographer: Paolo Roversi
Client: Alberta Ferretti
Date: 1999

39
Photographer: Dah Len
Hair: Rick Giradone for Oribé
Makeup: Yasuo Yoshiikawa
 at L'atelier
Stylist: Danny Santiago
Publication: Detour
Date: 1999

40 & 41
Photographer: Tim Walker
Makeup: Ruth Funnel

Stylist: Grace Cobb
Publication: Italian Vogue
Date: 1999
Designer: Prada

42
Photographer: Christian Witkin
Model: Safkia
Hair: Kevin Wood
Makeup: Ayako
Stylist: Robin Raskin Solis
Publication: Harper's Bazaar
Date: 1999

43
Photographer: Tom van Heel
Model: Emanual
Hair & Makeup: Sil at House
 of Orange
Stylist: Jos Van Heel
Publication: Squeeze
Date: 1998

44
Photographer: Rankin
Model: Sarah Holland
Makeup: Jackie Hamilton Smith
Stylist: Miranda Robson
Publication: Dazed & Confused
Date: 1998

45
Photographer: Christophe Rihet
Publication: Allure
Date: 1999
Designer: Louis Vuitton

46
Photographer: Jeff Minton
Stylist: Scott Free
Publication: Detour
Date: 1999

47
Photographer: Elaine Constantine
Publication: The Face
Date: 1997

48
Photographer: Elaine Constantine
Publication: The Face
Date: 1999

49 & 50
Photographer: Jelle Wagenaar
Model: Annikaa
Hair: Joseph B.
Makeup: Jonnia Buick
Stylist: Daniella Jung
Date: 1998

51
Photographer: Tim Walker
Stylist: Sissy Vian
Publication: Italian Vogue
Date: 1998

52
Photographer: Alex Freund
Model: Petrina
Hair & Makeup: Nadine Suddaby
Stylist: Jiv
Date: 1999

53
Photographer: Stefan Ruiz
Client: Cat/Caterpillar Campaign
Date: 1998

54
Photographer: Stefan Ruiz
Client: Cat/Caterpillar Campaign
Date: 1998

55
Photographer: Johanna
 Martien Mulder

Model: Jirha
Hair & Makeup: Sil Bruinsma
Stylist: Richard Schroeffel
Publication: Purple
Date: 1999

56
Photographer: Johanna
 Martien Mulder
Model: M. Mulder
Publication: Sec. 5
Date: 1999

57
Photographer: Dana Menussi
Model: Camellia Clouse
Hair: Alan Whyte
Makeup: Linda Hay
Stylist: Natasha Federal
Publication: Spanish Harper's
 Bazaar (unpublished)
Date: 1999

58
Photographer: Dah Len
Date: 1999

59
Photographer: Dana Menussi
Model: Camellia Clouse
Hair: Alan Whyte
Makeup: Linda Hay
Stylist: Natasha Federal
Publication: Spanish Harper's
 Bazaar (unpublished)
Date: 1999

60
Photographer: Dana Menussi
Model: Amie Hubertz
Hair: Dan Sharp

Makeup: Stephan Dimmick
Stylist: Natasha Federal
Publication: Madison
Date: 1999

61
Photographer: Johanna
 Martien Mulder
Model: Jinha
Hair: Sil Bruinsma
Stylist: Richard Schreeffel
Publication: Purple
Date: 1999

62
Photographer: Marie-Jose
 Jongerius
Model: Peggy
Publication: View on Color
Date: 1998

63
Photographer: Jeremy Murch
Model: Liudmilla
Stylist: Fiona Dallenegra
Publication: i-D
Date: 1999
Designer: W<, Zucca, Birken-
 stock (sandals)

64
Photographer: Mark Mattock
Model: Esther Cañadas
Publication: Swedish Elle
Date: 1999
Designer: Alexander McQueen

65
Photographer: Stephane
 Sednaoui
Model: Laetitia Casta
Publication: Detour
Date: 1998

66
Photographer: Paolo Roversi
Makeup: Frank B. at DWNY
Stylist: Alice Gentilucci
Publication: Italian Vogue
Date: 1998
Designer: Hermes

67
Photographer: Michael
 Thompson
Model: Linda Evangelista
Publication: W
Date: 1999

68
Photographer: Kent Baker
Hair: Johnny Drill
Publication: Guardian (fashion
 issue)
Date: 1998

69 & 70
Photographer: Rankin
Client: Diesel Style Lab
Model: Laura K
Hair: Peter Gray
Makeup: Charlotte Tilbury
Publication: Diesel catalogue,
 Dazed & Confused
Date: 1998

71
Photographer: Mark Mattock
Model: Clara
Hair: Eugene Soulieman for
 Trevor Sorbie at Streeters UK
Makeup: Lisa Butler at
 Streeters UK
Stylist: Judy Blame
Designer: Rifat Ozbek, Philip
 Treacy (hat)
Date: 1998

72
Photographer: Michael
 Thompson
Model: Honor Fraser
Publication: W
Date: 1999

73
Photographer: Sarah Moon
Client: Christian Lacroix
Model: Pauline
Date: 1997

74
Photographer: Sarah Moon
Client: Issey Miyake
Model: Kassia
Date: 1997

75
Photographer: Umberto
 Stefanelli
Date: 1999

76
Photographer: Cleo Sullivan
Models: Emma Griffiths, Kae,
 Zi Ling
Makeup: Julie Began
Publication: Show
Date: 1999

77
Photographer: Cleo Sullivan
Models: Kae, Zi Ling
Makeup: Julie Began
Publication: Show
Date: 1999

78
Photographer: Wendelien Daan
Model: Anne Marie
Hair & Makeup: Ines Morreau
 & Manous

Stylist: Suleyman Demir &
 Sabine Jansen
Publication: Rail 5
Date: 1998

79
Photographer: Kent Baker
Client: Steidel Publishers
Model: Mica
Hair: Adam Bryant
Makeup: Sharon Dowsett
Stylist: Felix
Publication: Strip
Date: 1998

80
Photographer: Jamil GS
Stylist: Jason Farrer
Publication: Spin
Date: 1999

81
Photographer: Taryn Simon
Date: 1999

82
Photographer: Jamil GS
Date: 1999

83
Photographer: Taryn Simon
Date: 1999

84 & 85
Photographer: Dah Len
Date: 1999

86 & 87
Photographer: Larry Sultan
Client: taken on set of *Teach
 Me* and *Personal Time*,
 directed by Thomas Paine

Hair & Makeup: Terry Groves
Stylist: Gabriel Feliciano
Publication: L'Homme Vogue
Date: 1999

88
Photographer: Gillian Laub
Models: Jordana Hoyt, Choki
 Lindberg, Mikael Schulz
Hair: Carol Raimer
Makeup: Eric Polito
Date: 1999

89
Photographer: Alex Freund
Model: Nadine
Hair & Makeup: Nadine Suddaby
Stylist: Jiv
Date: 1999

90
Photographer: Bettina Rheims
Model: Claudia Schiffer
Hair: Barnabe at Jean-Louis
 David
Makeup: Lloyd at Carol
Stylist: Gabriel Vazquez
Publication: Detour
Date: 1999

91
Photographer: Ellen von Unwerth
Model: Shalom Harlow
Publication: Italian Vouge
Date: 1989
Designer: Alberta Ferretti,
 Philip Treacy (hat), Patrick
 Cox (shoes)

92
Photographer: Elaine Constantine
Model: Stella Tennant
Publication: W
Date: 1999

93
Photographer: Larry Fink
Models: Rae Leigh, Franka
 Trump, Jared Paul Stern
Hair & Makeup: Amanda Pratt
Stylist: Cessy Lima, Ann Caruso
Publication: Detour
Date: 1999

94
Photographer: Elaine Constantine
Publication: The Face
Date: 1998

95
Photographer: Jennifer Robbins
Hair: Matthew Williams
Makeup: Edward Cruz
Stylist: Colleen Brennan
Publication: Detour
Date: 1999
Designer: D&G Dolce & Gabbana,
 CK Calvin Klein

96
Photographer: Jennifer Robbins
Model: Brittney Murphy
Hair: Roberto Ramos
Makeup: Kara Yoshimoto
Stylist: Nina & Clare
Publication: Detour
Date: 1999

97
Photographer: Elaine Constantine
Publication: The Face
Date: 1997

98
Photographer: Tim Walker
Publication: Italian Vogue
Date: 1999
Client: Blumarine

Acknowledgments

My thanks are due firstly to all the photographers who have graciously participated in this project – with their time, support, and wonderful photographs.

The editors and art and photography directors of many magazines and galleries have been extremely helpful – but I have a particular debt to Shannon Hall, who I turned to on a regular basis. I would also like to thank Franz Ankone; Dena Bunge at Harry N. Abrams, Inc.; Bill Charles; Felix Den 'Yurt at Camilla Lowther Management; David Maloney, Craig Hildreth, and Jordan Shipenberg at Art Department; Jed Root; Marco Santucci; Sarah Seyfried and Patrick Corcoran at The Agency; Jan Stevens at ESP; Betty Wilson; Ziggy and Maaike at Z Photographic.

As always I rely on my friends and cohorts as well, and I certainly couldn't have done this without the advice and counsel of Jesse Browner, Maro Chermayeff, Ivan Chermayeff, Judy Clain, Jane Friesen, Lizzie Himmel, Michael Kazam, Frank Parvas, and Barbara von Schreiber. My warmest thanks go to my editor, Ruth Peltason, who has an invaluable eye and was beyond patient when I was so very "fashionably late." Also to Judy Hudson, who brought an inspiring and strong design to this book. Lastly, to Jonathan, Loulou, and Fanny, who always come first.

Catherine Chermayeff

Editor: Ruth A. Peltason
Designer: Judith Hudson

**Library of Congress Cataloging-in-
Publication Data**
Fashion photography now / edited by
Catherine Chermayeff.
 p. cm.
ISBN 0-8109-2712-8 (pbk.)
1. Fashion photography. I. Chermayeff,
Catherine.

TR679.F377 2000
778.9'974692–dc21 99-53247

Printed and bound in Italy
by Canale & C. S.p.A.

Harry N. Abrams, Inc.
100 Fifth Avenue
New York, N.Y. 10011
www.abramsbooks.com